LIGHT AND SHADOW IN DRAWING

BARRON'S

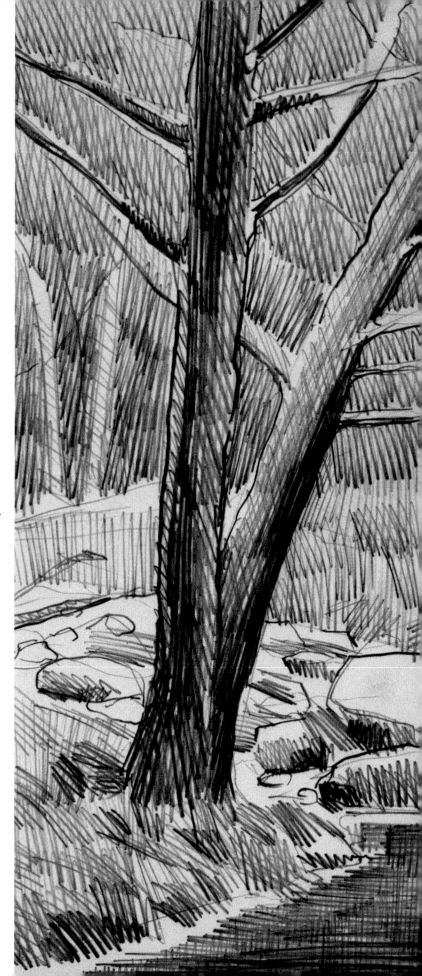

© Copyright 2006 of the English-language edition by Barron's Educational Series, Inc.
for the United States, its territories and possessions, and Canada

Original title of the book in Spanish: *Academia de dibujo: La luz y la sombra
en el dibujo*
© 2005 Parramón Ediciones, S.A.—World Rights
Published by Parramón Ediciones, S.A., Barcelona, Spain.
Text: Gabriel Martín Roig
Exercises: Carlant, Almudena Carreño, Mercedes Gaspar, Gabriel Martín, Esther
Olivé de Puig, Óscar Sanchís
Photographers: Nos & Soto

English translation by Eric A. Bye, M.A.

All inquiries should be addressed to:
Barron's Educational Series, Inc.
250 Wireless Boulevard
Hauppauge, New York 11788
www.barronseduc.com

3 9082 10015 1011

ISBN-13: 978-0-7641-5990-9
ISBN-10: 0-7641-5990-9

Library of Congress Control Number: 2005909289

Printed in Spain
9 8 7 6 5 4 3 2 1

CONTENTS

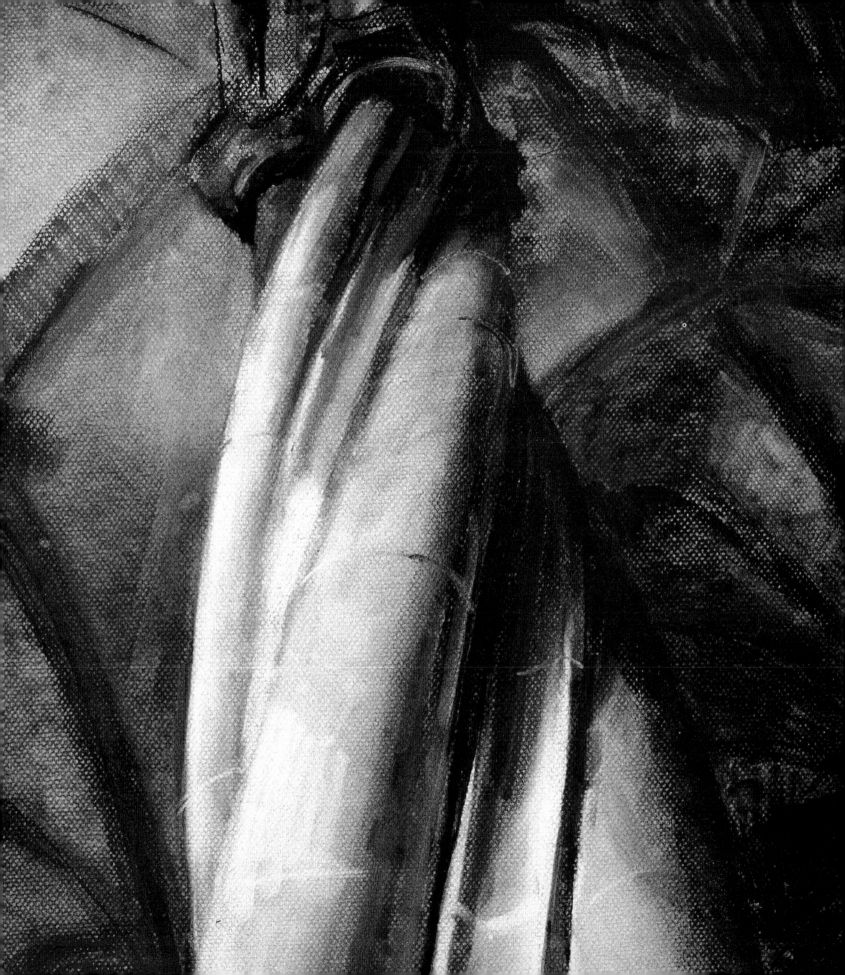

INTRODUCTION

Without even realizing it, we make use of the information provided by shadows. Shadows make it possible to recognize the shape of the three-dimensional objects that are all around us, define surfaces, and indicate the time of day. Lighting is one of the most important questions in drawing. Learning to draw requires learning how to see shadows and represent them with all of their inherent logic. (We always refer to *shadows* rather than to *light*, because the base for the drawing, the paper, is generally white.)

Shading is the resource most commonly used in drawing manuals, and it's one of the most time-consuming ones to learn. The reason is that shadows are not distributed arbitrarily; rather, they are constrained by systematic rules that determine their position, shape, extent, and density.

Technical control in the distribution of light and shadow is a crucial, defining factor that must be learned if we wish to endow the depiction with greater realism. Shadows serve to soften the light, create dramatic effects, and stamp the work with a certain emotional atmosphere. They are the emotional key to the work and make it possible to give it a greater pictorial treatment.

Of course, it's possible to choose to draw exclusively with lines and forgo all use of shading; however, the drawing comes closer to the original model precisely through the intervention of light and dark areas. The more tonal information the representation contains, the more realistic it appears.

In this manual we will see some methods for rationalizing the shading in drawings and getting the most out of their representation. We will study shadows' correct relationship to light, how to draw them using the most common resources and methods, and how to represent shapes with the basic techniques of chiaroscuro in order to produce the effects of three-dimensionality and depth we desire in our work. To facilitate learning, selected exercises provide an opportunity to put into practice a broad repertory of techniques and effects.

SHADOW AS AN ELEMENT OF CONSTRUCTION. Shading affects all drawing techniques equally because it is the basis for constructing shapes, it affirms their structure, and it contributes information about the shapes of the objects. In addition, it helps reinforce the physical appearance of the objects and their location in space.

SHADOW AS THE ORIGIN OF ART. Western art originated in shadow. Its beginnings are the silhouette figures on cave walls. Through the centuries, art has ceased to be a "representation of shadow" and has turned into drawing that uses shadow along with other means of depiction and representation.

SILHOUETTE. At the start of the nineteenth century, it became popular to draw silhouettes using a single tone of shadow. Even though light areas were not used, it's easy to distinguish the face in profile.

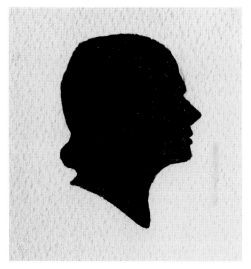

Incorporating shadow into a drawing helps give it a more pictorial treatment.

Head in profile. Shadow makes it possible for us to grasp the shape through contrasts in tone.

THE SHADOW OF AN OBJECT. Shadow reinforces the objective and tangible concept of the object and makes the whole and the parts that make it up comprehensible. The mere appearance of shadow on any object determines the imaginary relationship of the object with its surroundings. Wherever the light strikes the object, shading is needed to represent the parts that are in shadow and give them a solid shape.

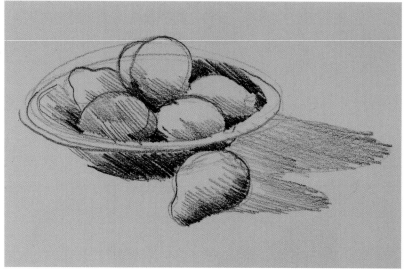

If we compare the two drawings, we see that the still life with the shading has more solidity and physical presence than the one constructed using only lines.

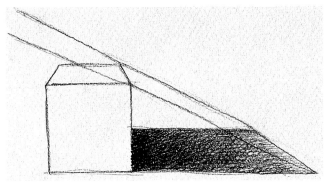

PROJECTED SHADOW. A shadow produces dramatic effects in the drawing because it represents a distorted image of the object. In addition, it helps to fix the model in the surrounding space and to situate the source of light.

A projected shadow constitutes a duplicate of the object on a nearby surface.

The extent and the direction of the projected shadow provide lots of information about the light source and the location of the object in relationship to it.

A HOMOGENEOUS TONE

The first treatment of shadow must be uniform and homogeneous. A uniform shading can be done using several controlled passes with charcoal compound crayons, chalk, or a graphite pencil. Uniform shading complements the information provided by the lines and gives the drawing more solidity and body.

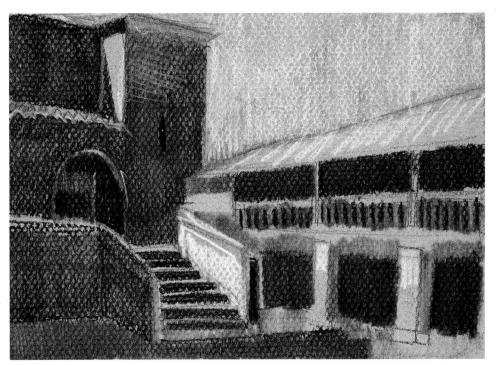

Shading gives the lines more physical presence. A few uniform grays create the contrast necessary for distinguishing the recesses and projections in the façade.

SHADOW AS A PICTORIAL CATEGORY. Line is the unique and distinguishing characteristic of drawing. Shadow breaks the edges, cancels out contours, and negates profiles. The line yields to shading, which is the property of painting. That's why shadow raises drawing to the category of the pictorial.

CONSTRUCTION BLOCKS. Shadow is the absence of light. It can also be defined as "comparative darkness caused by the interruption of sunlight." For the painter, shadows are the construction blocks that are used to create a convincing illusion using the elements of a painting.

If we synthesize the shading, the drawing appears to be a construction made up of blocks of different tones.

THE POWER OF CHARCOAL. Charcoal is the drawing medium most similar to painting. It is a monochromatic tool that is capable of a great range of registers, from large areas of dark, velvety tones to works of fine, delicate lines. Charcoal also makes it possible to shade quickly with dark tones that cover well. In addition, it can easily be erased with the finger, a cloth, or an eraser.

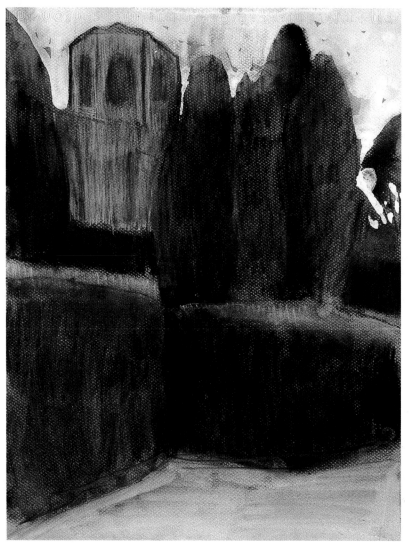

Charcoal produces intense blacks and a finish similar to painting.

THE NEGATION OF EDGES. Shadow cancels out the edges of shapes and sets up confusion. As a result, it creates a certain sensation of atmosphere and instills life into the picture. In addition, shading provides depth and volume, and it helps objects blend in with the background.

A

B

C

D

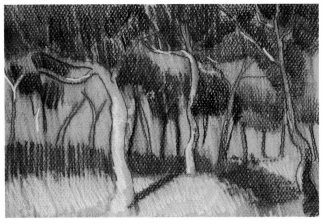

In a linear drawing, shadow softens the edges and produces a lack of precision. This treatment may be appropriate for depicting vegetation.

Shading can be done in a tonal fashion (A) or by using gradation (B), hatching (C), or sfumato (D). The latter two are the ones that most obscure the linear edges and modify the outline previously established by line.

WORKING WITH FEW VALUES. The simplest process for beginning to apply shading involves working with a restricted range of values. Two or three tones can be used to represent dark, medium, and light shadow. The resulting schematic drawing is a good point of departure for developing new shadows, details, and corrections.

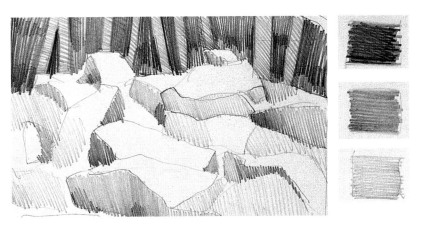

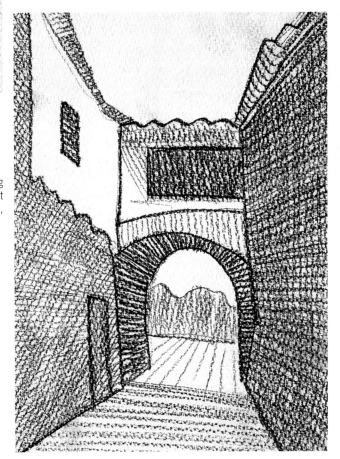

In drawing a landscape, we can begin with blocks of shading with just three values: dark gray, medium gray, and light gray.

In this sketch done in tonal zones, the shadows were created using only a few values by varying the crosshatched lines. The treatment is very synthetic.

The Effect of Light

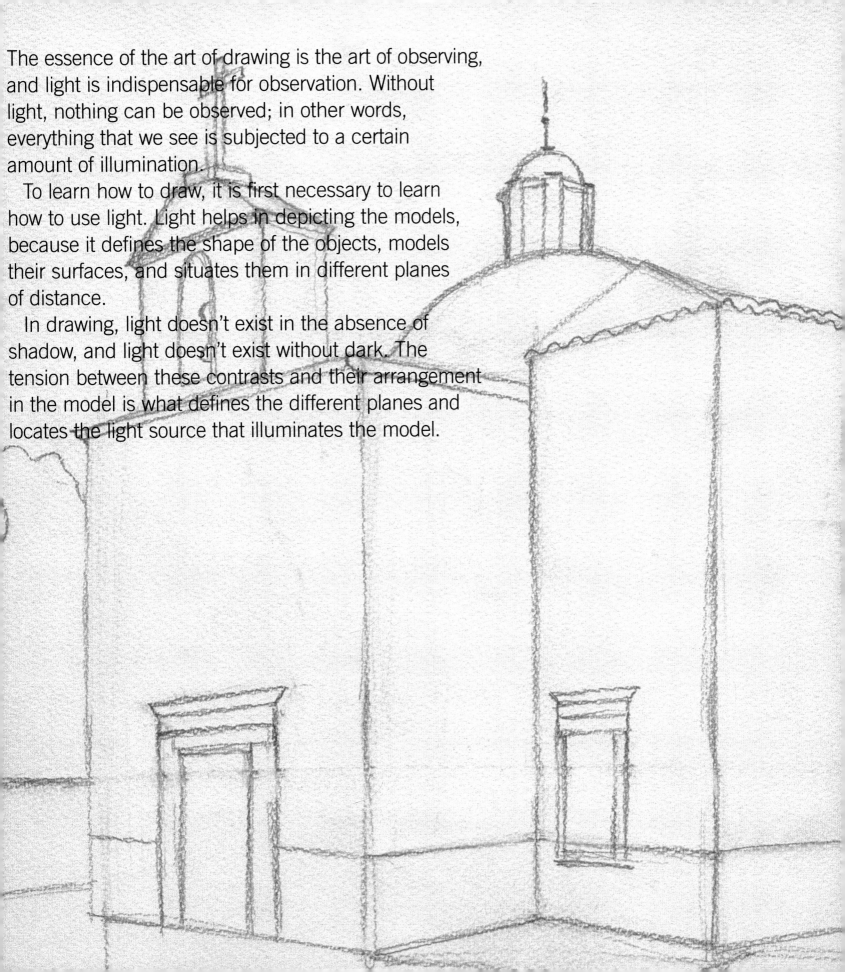

The essence of the art of drawing is the art of observing, and light is indispensable for observation. Without light, nothing can be observed; in other words, everything that we see is subjected to a certain amount of illumination.

To learn how to draw, it is first necessary to learn how to use light. Light helps in depicting the models, because it defines the shape of the objects, models their surfaces, and situates them in different planes of distance.

In drawing, light doesn't exist in the absence of shadow, and light doesn't exist without dark. The tension between these contrasts and their arrangement in the model is what defines the different planes and locates the light source that illuminates the model.

CONTRAST AS A TOOL OF EXPRESSION. Just as it is possible to draw using only lines, it is possible to draw using only shaded areas. Drawings done merely with areas of tone and shading are filled with atmosphere and charm. By studying how the model receives light, and recording it with shades and tones, it is possible to produce a very convincing sketch.

1.1

SKETCHING WITH TONE. One excellent way to learn how to see and draw shadows is to use a single tone or value. You will be surprised to see how much a single tone can communicate about the appearance of the model.

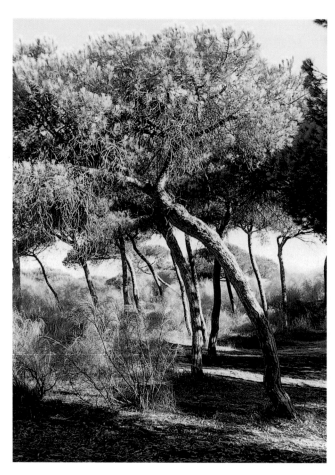

We begin the representation of the model by using a piece of 2B graphite lead held sideways to trace the shape of the tree trunks in the foreground and the shadows they cast on the ground. We're not interested in details. Our goal is to create a certain contrast between the gray areas and the white of the paper.

We complete the area of shadow in the underbrush and the lower part of the crown of the trees with new shadings in the previous tone. By way of contrast, the light areas on the paper represent the illuminated parts of the model.

To produce a uniform tone in this first layout phase using shadows, we cut off a piece of graphite lead and use it held flat.

We use an eraser to lighten the right side of the tree trunks and make them appear illuminated.

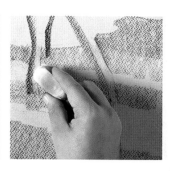

1.2

CONTRAST USING TWO TONES. Using a second tone makes it possible to differentiate the darkest shadows and the medium tones of the sketch. A greater contrast of the shadows with the white of the paper highlights the illuminated areas.

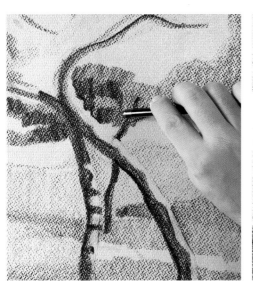

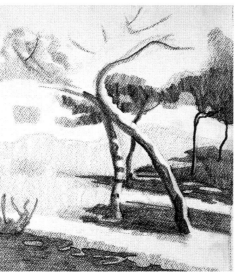

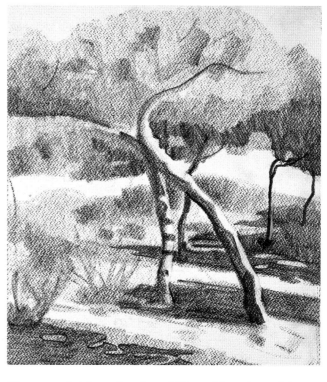

We put aside the graphite lead. We now take a whole lead in grade 4B, which allows for darker grays. Holding the point of the lead at a sharp angle, we spread out areas of darker gray. These shadings must be less abstract and conform a bit more to the shapes of the model.

To the previous grays we add a darker shading in the lower part of the paper and in the crown of the trees. Now there are two intensities of gray in each shadow.

We once again take up the piece of 2B graphite and complete the foliage of the trees with light shadows, preserving the white areas of the paper that represent the illuminated parts. Drawing by Gabriel Martín.

If you want to finish the drawing a little more, you can add more contrast to the shadows and complete the grove by depicting the trees in the farthest plane.

VALUES GUIDELINES. In a drawing, the values guidelines are the breakdown of the subject into all its tonal shapes—light, dark, and intermediate tones. They include the light guidelines, which correspond to the white of the paper, and the shadow guidelines, which we achieve by gradually darkening the tone of the gray.

2.1

GENTLE SHADING AND LIGHT. We begin the drawing by applying a very slight initial shading to the whole shaded area of the model; this will be the lightest tone of shadow. We preserve the white of the paper in the illuminated areas.

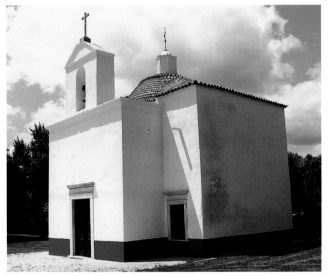

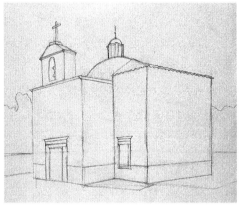

We add the proportions of the chapel to a previously drawn skeleton; it can be represented with two overlapping cubical shapes. When the structure is complete, we carefully draw the openings in the buildings and the other architectural features.

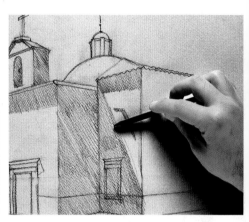

We establish the illuminated areas of the wall, which we preserve using the white of the paper. Then we use an HB graphite lead to shade the façades of the chapel with gentle, oblique strokes, following the direction of the sun's rays.

To draw the building correctly, we draw five vertical lines that represent each of its sides, keeping in mind that the main and the side façades are the broadest ones.

We connect the vertical lines with diagonal ones at the bottom and top to achieve a credible effect of perspective.

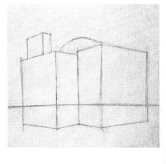

2.2

MEDIUM AND DARK SHADOWS. Any model can be deconstructed into an arrangement of shapes in different values: light, dark, and intermediate. The shadows are uniform blankets that contrast with the adjacent ones through the change in tone. This interpretation of the model makes drawing it much easier.

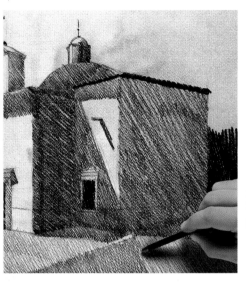

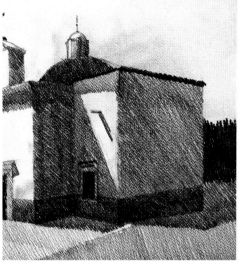

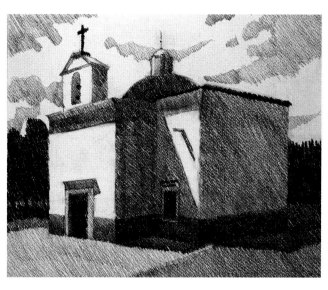

Using a 4B graphite lead we fill in the line of trees in the distant plane and the openings in the building with very dark lines. We use a gray to further darken the shaded façades of the building. The initial gray is retained for the paving on the ground.

We darken the bluish border along the base of the walls to differentiate it from the rest of the façade. We also add some contrast to the shadow cast by the building to distinguish it from the gray of the lawn.

Each tonal area must be clearly differentiated from the adjacent ones to make the volume and the architectural elements of the building stand out. To conclude, we shade in the blue of the sky and leave the clouds white. Drawing by Gabriel Martín.

If the hand accidentally rubs across the paper, it may smudge those areas where the intensity of the white must be preserved. To avoid this, it is necessary to clean up those areas with an eraser.

A single tone—a very soft gray—is adequate for depicting the clouds. If we color in the blue areas, the outline of the clouds will appear synthesized through tonal contrast.

STUDYING THE MODEL IN DIFFERENT LIGHT.

For outdoor scenes the sun is the best source of light, but it has one disadvantage: its continual movement. However, this movement also means it offers plenty of variety for shading.

Before starting a drawing, it's appropriate to view the model in all types of light during the day and study how it changes. This allows us to become familiar with the effects of light and to choose the best moment.

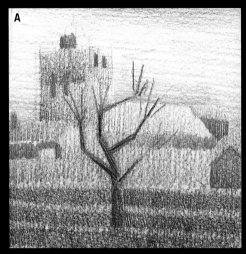

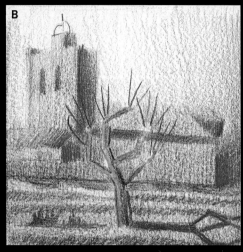

Because of the movement of the sun, the shadows in a landscape vary throughout the day. Here are two examples of the same model with the sun in a lateral position (A), and at dawn (B).

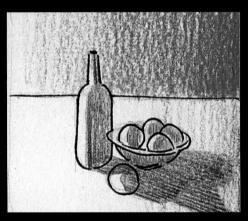

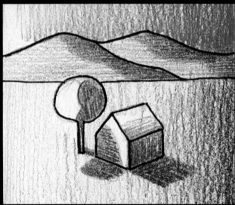

LATERAL LIGHT. When the light hits a model from the side and a slightly elevated point of view, it produces sharp contrasts of light and dark that reveal the shape and the texture of the subject, presenting a broad range of shadows that define the areas surrounding the object. The illuminated parts of the objects remain on the side where the light source is located.

Lateral light causes strong contrasts and casts long shadows on the side opposite the light source.

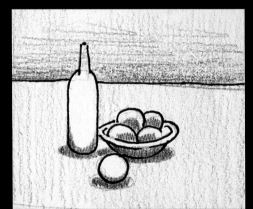

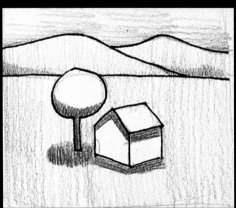

OVERHEAD LIGHT. Light from above falls vertically onto the shapes. It projects very small shadows right under the objects. The lightest and warmest areas of the subject restrict the planes that form a right angle with the light.

Overhead light casts very small shadows right below the objects.

THE LIGHT SOURCE. We can best understand light and shadow and how they behave on shapes by examining the changes that the same model experiences when subjected to light of different types and from different sources.

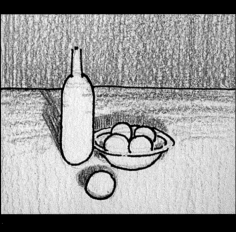

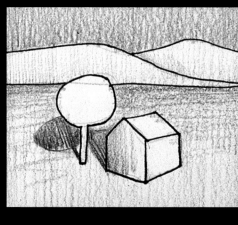

FRONTAL LIGHT. Frontal light reaches the model from the position of the observer, so the foreground is lighter. The farther away the object, the deeper and the colder its tones. Light predominates over shadows in the model, because the shadows are projected behind the objects. Frontal light offers the artist the opportunity to work with a lighter and brighter palette.

With frontal light, the resulting shadows remain obscured behind the objects; they are not visible, and there are no localized shadows on the objects.

BACKLIGHTING. In backlighting, the model receives the light from behind, and the visible planes are in shadow. The features of the landscape are reduced nearly to silhouettes. In this scene the sky is the brightest and warmest area in the composition. The ground plane is lightened and its color becomes warmer as it approaches the light source on the horizon.

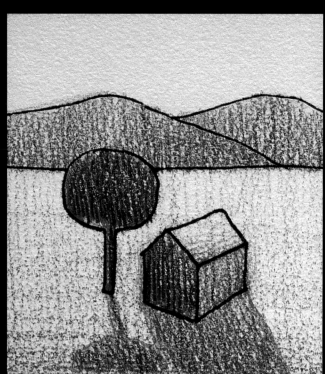

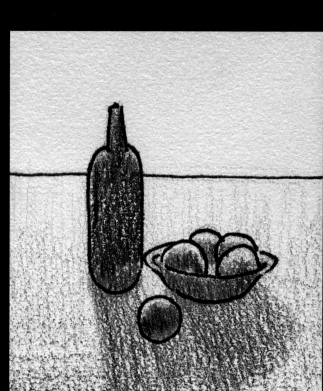

In backlighting, the rear of the model is illuminated. The visible planes remain in shadow because the shadows that are cast advance toward the observer.

STILL LIFE WITH NATURAL LIGHT. The light that enters through a window early in the morning is somewhat diffuse, and it produces soft shadows without much contrast. It's excellent for developing gradations with a graphite pencil, one of the means of drawing that makes it possible to model objects with great delicacy.

3.1

A SOLID DRAWING. The shading process becomes much simpler if the line drawing on which we work has well-defined outlines and shapes, and a strong, defining line; that helps avoid confusion and errors that must be corrected. Starting with a solid drawing allows us to concentrate solely on the shading.

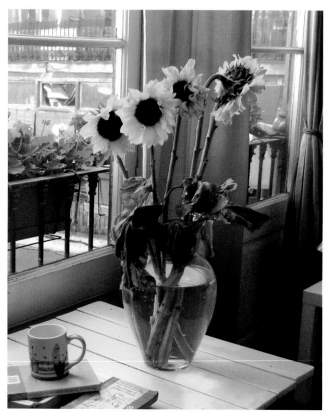

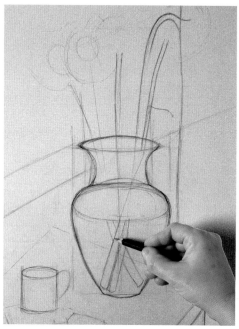

We draw the outline of the vase in darker lines on a layout done previously. It must be symmetrical, for the whole composition depends on the vase. We use faint lines to suggest the stems of the flowers.

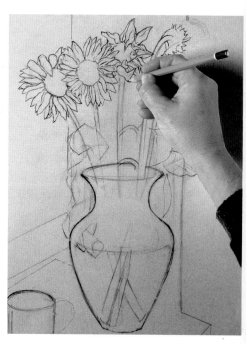

We resolve precisely and clearly the other focus of attention in the subject: the sunflowers. The treatment is totally linear and addresses the exact shape of every petal, in a very naturalistic interpretation.

If we first draw a box and divide it into halves with a straight vertical line and draw the vase inside it, maintaining the symmetry becomes easy.

The thickness and intensity of the line need to vary according to whether it depicts the exterior of an object, in which case it is thicker and firmer, or lines inside the leaves, which are less distinct, thinner, and less precise.

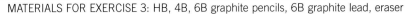

3.2

ATTENUATED CONTRASTS. We apply the shading to a drawing done exclusively with very bold lines, paying attention to every important detail of the model. Gradation and attenuated chiaroscuro (shading from intense light to dark) predominate in this treatment, because the model is bathed in a diffuse light.

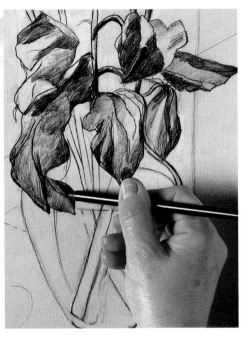

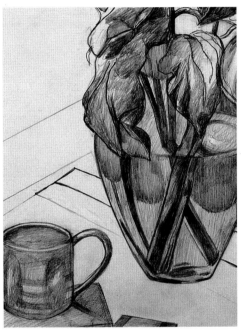

We begin with the leaves. First we decide which areas to leave white to represent the ones that receive the most light. Then we develop the gradations in the other areas using small tonal differences that depict the folded, undulating surface of the leaves.

The inside of the glass vase is created using uniform, clearly differentiated tonal areas. There is scarcely any contrast between the grays of the cup and the blocks at the bottom. In this phase it works well to alternate between the 4B graphite pencil and the 6B graphite lead.

We shade the background using uniform strips of gray by bearing down very gently with the 6B graphite lead. To avoid distracting attention from the main subject—the vase and the sunflowers—the surrounding area is left free from details. Drawing by Almudena Carreño.

The corolla of the flowers is taken as the point of greatest intensity in the drawing. This contrast is an important lure for the observer's gaze.

We use a 6B graphite pencil to define some shadows and outlines of the leaves to keep them from blending together and losing their identity.

INDOOR SCENE WITH ARTIFICIAL LIGHT. Artificial light is very attractive for drawing an indoor scene, because all the light that fills the scene comes from a single point. Thus, all the sides of the objects facing the light appear in illumination.

4.1

RECTANGULAR AND RHOMBUS SHAPES. We have chosen a corner of a house illuminated by a small electric lamp, and containing a set of simple everyday objects. All the items have a simple shape that can be reproduced using straight lines and rectangular and rhombus-like shapes. We do a line drawing of them before starting to add the shading.

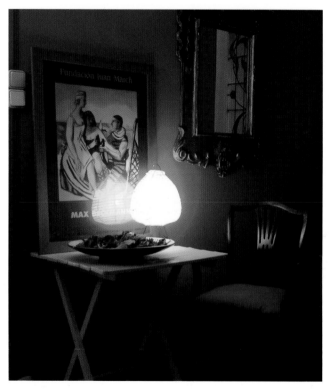

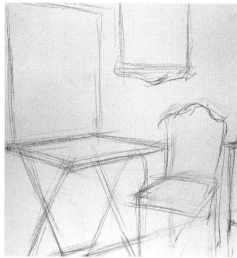

The initial layout attempts to establish the objects using quadrangular shapes in the painting and the mirror, and rhombus-like shapes in the table and the chair. The treatment is very gentle, caressing the paper with the tip of a charcoal stick.

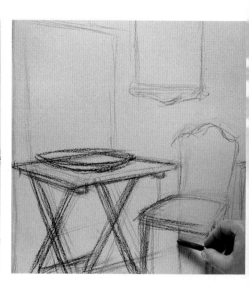

When the faint lines appear convincing, we go over them again to darken them. We attempt to resolve the shape of each object, but without focusing on details or textures.

Doing the preliminary sketch in very faint lines makes it possible to erase very easily and make corrections in case of errors.

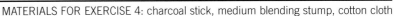

4.2

LIGHT AND ATMOSPHERE. The effect of shading must not only represent the radial dispersion of light, but also recreate the atmosphere and the illumination that bathes the objects. In this case, the illumination is intimate, and the contrasts are moderated. In shading the scene, a characteristic halo of light forms around the source of artificial light, and the rest of the scene appears darker than usual.

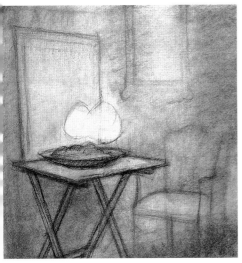

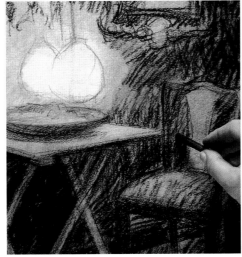

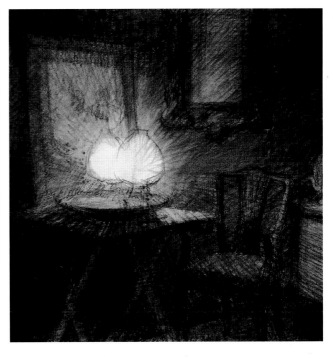

Using the side of the charcoal stick, we apply a general shading. We avoid covering the light source, the painting, which acts as a reflective surface, and the mirror in the background. Then we use our hand as a blending stump.

Over the shaded base we cover the walls and the chair with deep black in hatchings of more forceful lines. We leave a white area around the lamp, which serves as a halo of light.

Using a stump and new lines in charcoal, we shade off the shadows to produce more uniform grays. The lamp shades are the only things we leave white. Around them the white forms a smooth gradation until it changes into a nearly absolute black at the back of the room.

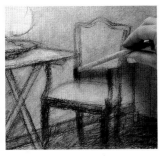

During the shading, it's appropriate to alternate between the charcoal and the stump to create a more homogeneous, integrated shading within the environment of the scene.

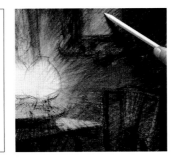

The radial effect of the light is created by tracing straight lines with the tip of the stump on the shading done in charcoal. We use the blending stump until the rays of light appear.

THE ANGLE OF LIGHT. The higher the location of the light source, the shorter and darker the shadow. If the light source is very low, the object casts a long and somewhat gradated shadow that becomes more diffuse the farther it goes.

USING GEOMETRY. The changing nature of light sometimes makes it difficult to represent certain shadows correctly. To resolve this difficulty, we can approach drawing these shadows based on projections in perspective, or simple geometric structures.

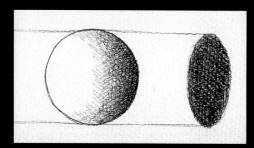

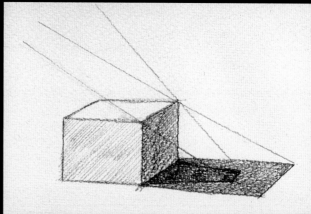

To correctly draw the shadow cast by an object, we draw lines projecting from the light source and passing along the edges of the object to arrive at the plane of the earth.

The shadow cast by a cube is long and displays a slight gradation, because the light source is low and lateral.

FORCEFUL ENVIRONMENTS. Shadow has great suggestive potential. We can take advantage of that to create environments that are filled with force and emotion by introducing secondary shadows projected onto the floor.

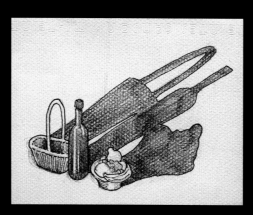

With oblique light, the shadow that the object casts takes on a life of its own and turns into a grotesque double image.

The projected shadow duplicates the shape of the figure and heightens the contrast along the outline on the left, adding expressiveness to the drawing.

PROJECTED SHADOWS. When an opaque object blocks rays of light, it casts a shadow onto a nearby surface. These projected shadows vary in size as a function of how high and how far away from the model the light source is. Projected shadows attach an object to the surface on which it rests and relate it to its physical surroundings, so it's very important to structure them correctly.

OBJECTS AND TEXTURES. Shadows cast onto a smooth surface appear straight and clearly defined; however, if they are projected onto some other object, or onto a textured surface, they change. When a shadow falls onto a three-dimensional object, it changes direction and conforms to the shape in a way that is rather similar to what happens with water.

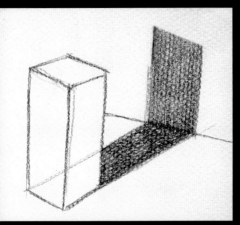

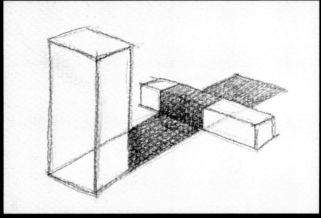

Shadows projected onto a smooth surface exhibit no changes; however, a shift in planes alters their direction.

When the surface onto which the shadow is projected displays texture, irregularity, or an obstacle, the shadow adapts to the surface and the shape of the object.

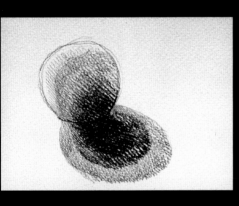

THE APPEARANCE OF HALF-LIGHT. Having multiple light sources means that instead of a single shadow of a homogeneous, dark tone, there appear areas of half-light that decrease the solidity of the shadows. A similar situation occurs when the light source contains a screen or a broad reflector, because the reflected light produces a halo of half-light around the shadow.

MULTIPLE LIGHT SOURCES. Working under different sources of light poses difficulties because shadows are cast in duplicate, and the area of semidarkness is much more extensive than the dark shadow.

The shadow is the dark area that the object projects when it interrupts the beam of light. The penumbra (imperfect shadow) is the lighter shade that surrounds the shadow. With an oblique illumination, the shadow cast by the object takes on a life of its own, and turns into a grotesque double.

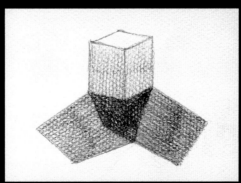

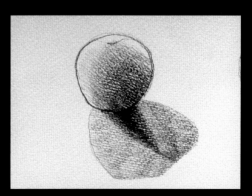

If more than one light source illuminates an object, the shadows projected are multiplied, and the imperfect shadow stands out.

The same sphere seen previously is now illuminated by two sources of light. It's obvious that the shadow has shrunk considerably, at the expense of the penumbra.

DIVISION BY TONAL AREAS. The basis for any contrast is the perceived difference between two tonal areas. A good exercise for learning how to construct shadows involves deconstructing a model into different, clearly delineated tonal areas. This allows us to formulate the drawing using planes of shadow as if we were dealing with a map of values.

5.1

THE INITIAL SKETCH. To produce an appropriate initial drawing, we do a very synthetic sketch of the landscape and another, more careful one of the cluster of buildings. The houses must be drawn well, and we have to pay attention to the pitch of the roofs and the directions of the façades.

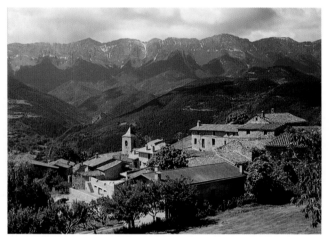

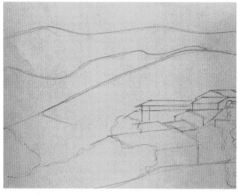

The first layout is schematic. With an HB graphite pencil we synthesize the outline of the mountains in the background, and using very light pressure we begin to sketch the houses by superimposing rectangular shapes.

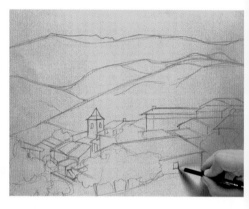

We determine the ultimate profile of the mountains by bearing down a little more on the ridge lines with the same pencil. We construct each of the houses on the existing geometric scheme, without adding many details.

The design of the houses requires more attention. They must be drawn with precision, using straight, firm lines, avoiding details and the texture of the walls.

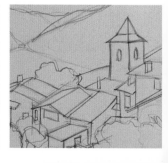

5.2

GENERAL TONAL SHADING. Creating the tonal map requires reducing the different tones seen in the model to just a few. The procedure begins by classifying the tones into two groups: light ones for distant planes in the landscape, plus medium and intense ones in the cluster of the village. We work from the general to the specific and begin by covering in the broadest areas of the landscape.

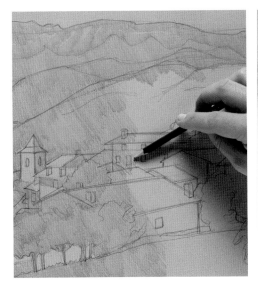

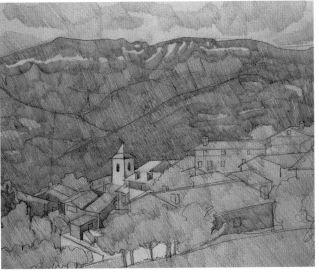

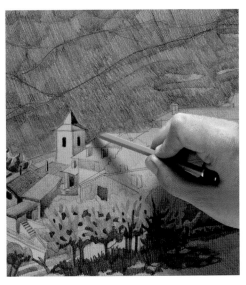

Using the HB graphite pencil held at a slight angle, we apply a generalized shading to provide an initial tone to the whole. This will be the lightest gray used in the composition. We preserve the white on the façades that are struck directly by the sunlight.

Over the preceding we apply a slightly darker shading to cover the vegetation in the background, except for some small areas on the mountains. Thus, with scarcely two values we succeed in making the cluster of houses stand out from the background.

Constructing the houses in the village with different tones is the slowest and most painstaking phase, because every façade is treated with a shade that is different from the adjacent ones. If we offset every illuminated façade with a shaded one, we achieve a competent and effective treatment of shadows.

To represent the shape and texture of nearby vegetation, we create a tonal scale: dark grays in the lower part of the trees, an intermediate tone in the center, and a light gray in the top.

As the pencil becomes worn down, the fingers approach the point and warm the lead, which softens and becomes stickier and denser, thus making it a little more difficult to create light tones.

5.3

TONAL SCALES AND CONTRAST. To keep the drawing from becoming fragmented, which would interfere with the overall perception of the composition, we have to keep the tonal variation gradual, rather than sequential and abrupt.

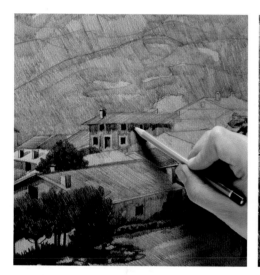

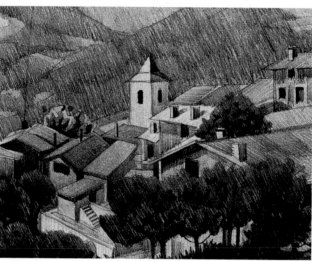

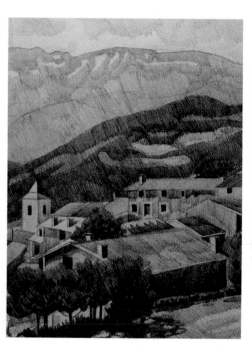

We finish shading the façades and highlighting the architectural details by means of tonal contrasts. It's a good idea to use just a few tones to avoid fragmenting the unity and harmony of the composition.

The strong tonal contrasts of the openings and the shaded façades define the shape and the relief of each building. Every wall and roof must be defined with a smooth gradation; the succession of these gradations creates a tonal whole that's fertile and visually very active.

By adding new passes with the 4B graphite pencil we darken the trees at the bottom. We apply a new, even tone on the mountains in the middle distance, leaving small spaces for the shading below to breathe. This new shading helps the outline of the houses stand out more.

In this phase the surface of the paper is covered with lots of graphite. To avoid smudging the drawing with the hand, and to work more comfortably, we protect the drawing with a sheet of paper.

The planes of the façades stand out from one another because of the abrupt changes of tone. This contrast is essential in order to avoid an excessively flat treatment of the houses.

The alternation of tones is crucial to the effect of three-dimensionality and the correct depiction of the irregularities in the landscape.

We darken the base of the mountains in the background with two broad, homogeneous applications of gray that exhibit an irregular outline. We now consider the drawing finished. It has taken us several hours, because a drawing with a complete tonal scale requires a patient development of values and detailed treatment. Drawing by Gabriel Martín.

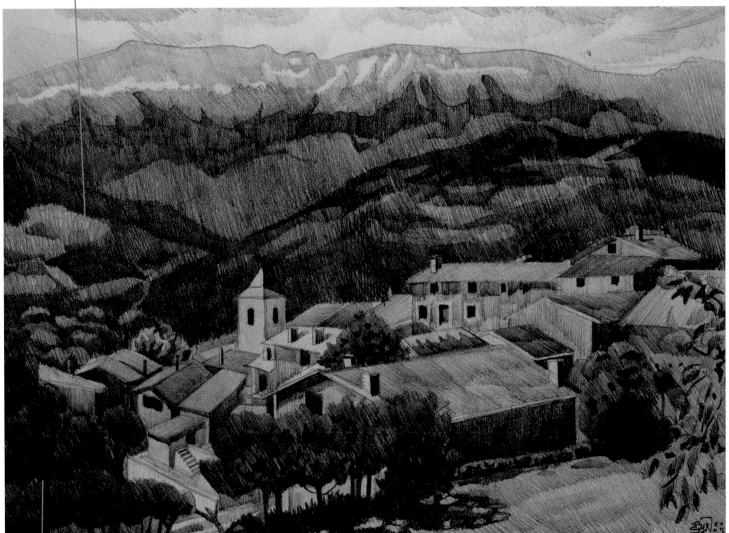

When working in superimpositions we must keep one key point in mind: the saturation of the paper. The paper reaches its maximum saturation point when its grain is totally covered and will accept no more pigment. This determines the darkest tone that the paper will retain. Thus, we have to know the maximum degree of saturation of the paper we are using in determining the darkest tone we can achieve and establish the system of tonal values on that basis.

Using tones of slightly different values on the grass at the bottom produces soft, light, and restrained effects.

VALUE AND TONE. The logic of light requires that we distinguish differences in shades of light and dark. These differences in shades are referred to as *values*. Light colors have a high value, and dark colors a low value. In monochromatic drawing, the terms *value* and *tone* are used in an indistinct manner, but that's not true in painting.

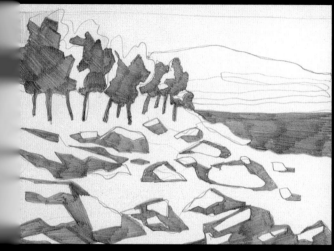

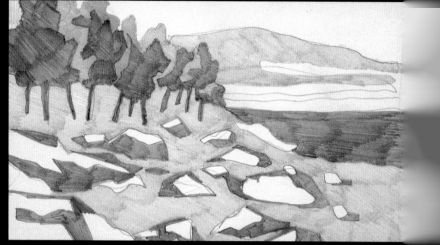

In a tonal drawing a homogeneous dark gray is first used to differentiate the most intense tones.

If we complement the previous shading with a medium gray, we achieve a tonal drawing with just three values: white, medium gray, and dark gray.

PRACTICING TONAL SCALES. Before starting the drawing, it's a good idea to practice some tonal scales on a separate piece of paper to check the subtlety of the lightest shading and the intensity of the total blacks that the paper is capable of producing.

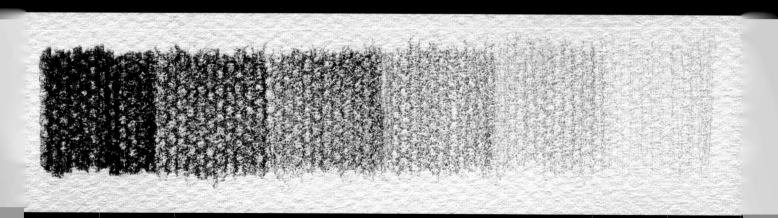

It's advisable to practice with a to

A SYSTEM OF TONAL DESIGNATIONS. The values of the drawing are the different intensities of a color that lightens or darkens a shaded object. The extremes of the valuation are white, the color of the paper, and the darkest tone that can be produced using the given medium. When working in black and white, these intensities are lighter and darker grays.

A SKETCH OF TONAL VALUES. Tonal studies must be expressed in drawing as a subject free from unnecessary details, like a succession of carefully arranged color blocks of homogeneous tone, a puzzle of monochromatic tones that, like a mosaic, offers us a fragmented view of the real model. This involves working with a complete scale of values ranging from absolute white to intense black. Between these two extremes there are literally thousands of tiny gradations.

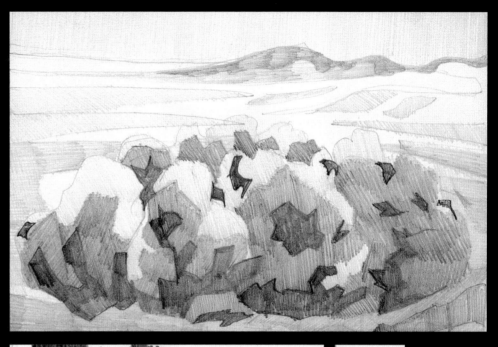

A small sketch will help resolve most important decisions because it makes it possible to foresee the large movements and shapes. It's advisable to work with just a few values— only four in this case.

INITIAL ORGANIZATION. Light and its effects can be used to organize the plane of the drawing before beginning work. Sketches are very useful in planning your composition, organizing the dynamics of its diagonals, and considering how to create an appearance of depth in the landscape.

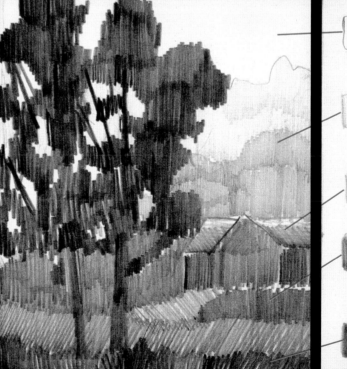

To create the effect of depth, the darkest tones must appear in the lower part of the drawing, and the lightest ones in the top part.

It's easy to see how we have put the adjoining theory into practice in such a way that the tones become softer and lighter as the planes of the landscape recede into the distance.

To keep the superimposition of tones from obscuring the shape of the object, there is one recourse that allows us to darken the background with a medium gray; the contrast thus makes it possible to distinguish the outline of the model more clearly.

The arrangement of tones is crucial for expressing shape and volume. To observe the effect, let's look at one shape constructed solely with lines (A), and another that includes shading of variable tonal intensity in each of its segments (B). The first comes across as a flat shape; the second provides a sense of three-dimensionality.

The effect of volume is achieved by constructing with tonal blocks. Each section is divided into clearly defined geometric sections. Then it is shaded in with just three or four tones of gray, without gradations or blending.

TONAL DESIGNATIONS: A CRUMPLED PIECE OF PAPER. To illustrate the effect produced by illumination on the surface of a crumpled piece of paper, we need to assign different tones to each area. Then, the paper, which is composed of numerous planes of different tones, presents a convincing sense of three-dimensionality. A graphite pencil is the medium selected for illustrating this method. The variations and the contrasts of values are produced by varying the pressure exerted with the pencil and by preserving the lightest areas of the paper.

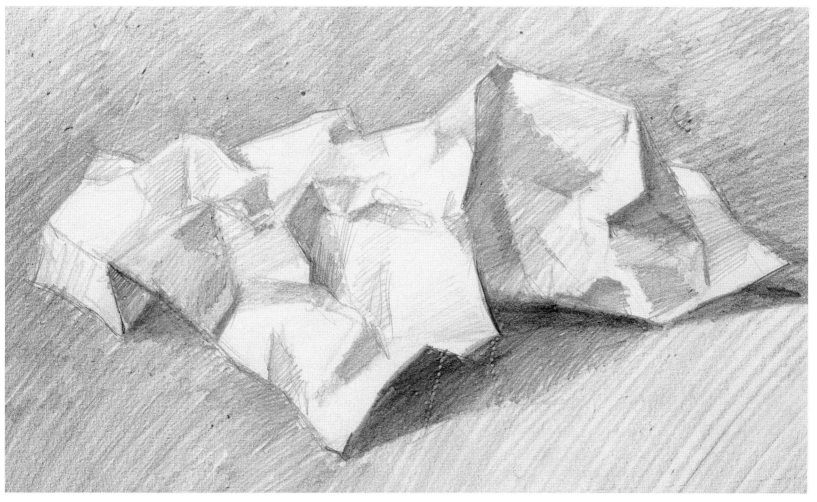

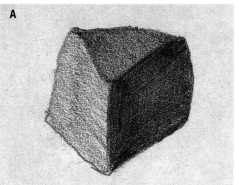

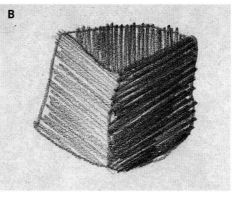

A study of the tones used in the drawing reveals a simple but very effective succession. The different planes are understood through the juxtaposition of well-structured grays of varying intensity.

In a drawing such as this one, there is an alternation between two types of shading: Some areas are resolved using uniform tones (A) that give the shape a more solid and compact appearance, whereas in other areas the shading includes hatching (B) that emphasizes the direction of the folds in the paper and constitutes a more dynamic treatment.

Shadow as Structure

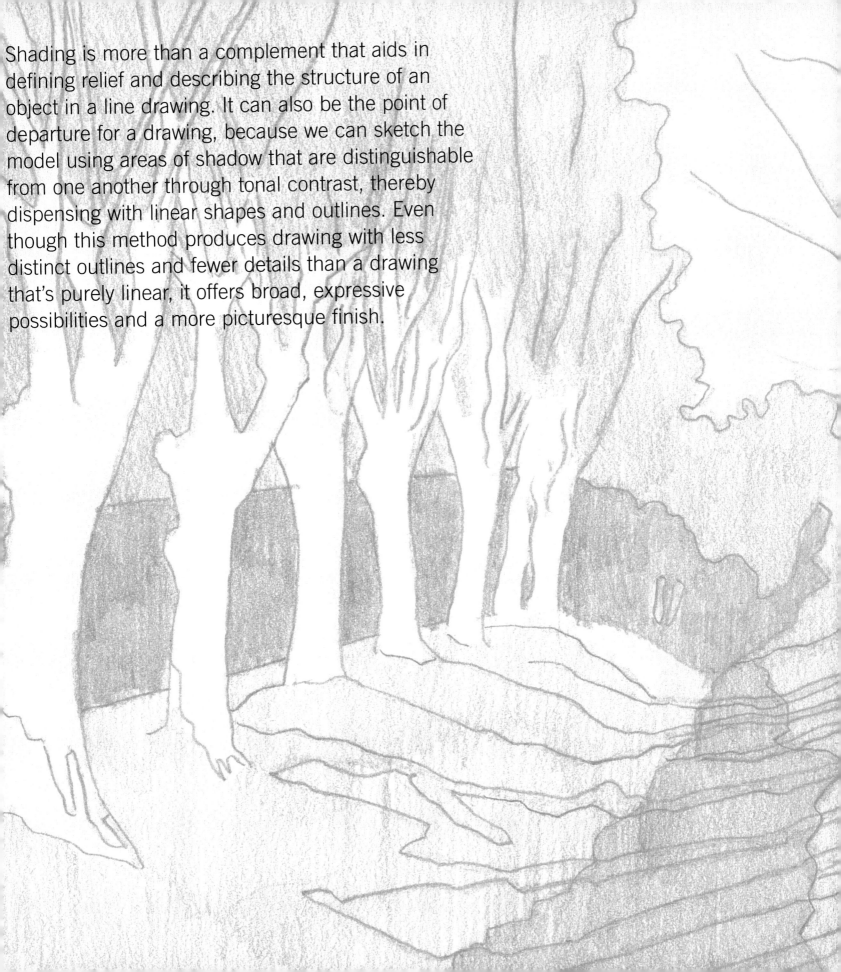

Shading is more than a complement that aids in defining relief and describing the structure of an object in a line drawing. It can also be the point of departure for a drawing, because we can sketch the model using areas of shadow that are distinguishable from one another through tonal contrast, thereby dispensing with linear shapes and outlines. Even though this method produces drawing with less distinct outlines and fewer details than a drawing that's purely linear, it offers broad, expressive possibilities and a more picturesque finish.

NEGATIVE SPACES. In this exercise we will discuss a very useful system for drawing complex outlines: using negative space. Negative space surrounds the model and shares its outline; as a result, when it is shaded in, the object takes on shape. In the exercise the columns with the flowerpots are the positive shapes, and the rest of the space is negative. We treat this negative space with shading that makes the positive spaces take on shape and turn into something real, offering a new perception of the object.

6.1

RESOLVING THE STRAIGHT OUTLINES. The lower part of the model is resolved using gentle grays, forming perfectly profiled geometrical tonal blocks that delineate the edges of the columns. The spaces that the columns are to occupy are left white.

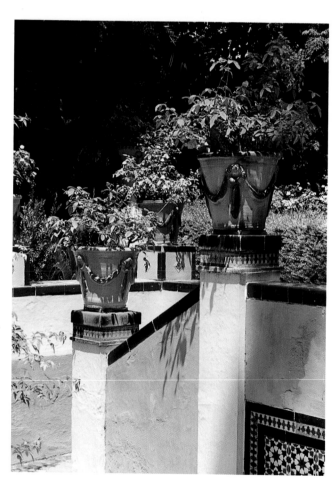

Using an HB graphite pencil we outline the columns, which appear white, by applying grays in the intervening spaces. The major difficulty lies in adjusting the angle of the diagonal lines that delineate the top of each area to create an effect of perspective.

We set aside the HB graphite pencil and take up a 2B to apply new tones of medium grays. Using a slightly darker gray, we distinguish the edge of the wall from the vegetation in the background, which we represent with a slight gradation.

The shading is gentle, with scarcely any abrupt changes in tone. All the strokes follow the same diagonal direction.

6.2

OUTLINING THE PLANTS. The greatest difficulty in this drawing is creating the outline of the plants. To handle this easily, we shade in the background, including the spaces between the flowerpots and the stems. When we're finished, the objects appear in profile against the white of the paper.

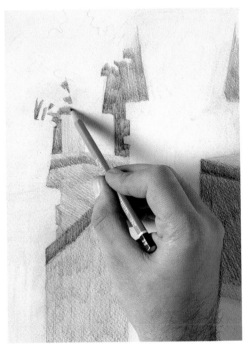

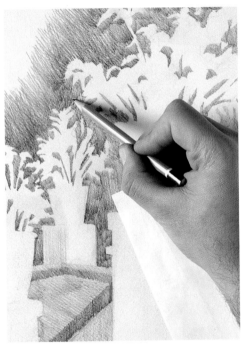

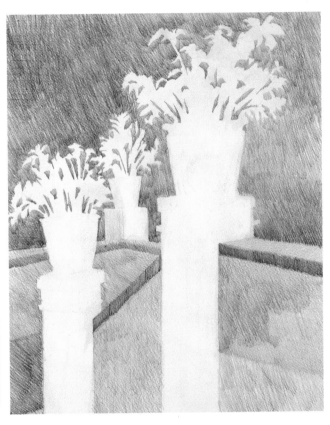

We give shape to the base of the flowerpots by carefully shading in the empty space between them. Then we use small areas of shading to depict the spaces that open up among the stems of the plants.

We continue by further outlining the leaves with additional shading. In this stage of the drawing, the surface of the paper is already covered with lots of graphite, and it's advisable to protect it from smudging by covering it with a sheet of paper.

We finish shading the outline of the columns and the flowerpots. The result is that they all appear to have been cut out of the drawing, leaving behind only their silhouettes. The work concludes here, but it can be perfected by correctly drawing the shapes and shadows inside the objects. Drawing by Gabriel Martín.

The object is not to draw the profile in pencil lines first and then add the shading without covering over the lines; rather, we use the very shading to create the drawing. In this exercise, it's the areas of graphite that construct the outline.

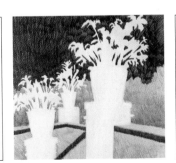

If we wish to differentiate and contrast the flowerpots even more, we darken the background with shading applied in 4B pencil, also remembering the open spaces among the stems.

MODELING. The use of a single tone for all the values of shadow is referred to as *modeling*. The illuminated areas are left in the white color of the paper. Thus, the shape of the model is distinguishable solely by means of a solid base of medium gray shadow that covers the whole paper and acts as a contrast with the white of the paper.

GUIDELINE FOR LOCAL VALUES. This is what distinguishes the basic difference in tone that exists between one color and another. This tonal difference is caused by the fact that some colors absorb more light than others. When a polychromatic model is reduced to black and white, the colors must find their equivalents in the scale of grays. As a result, every color is equivalent to a different tone of gray. This equivalence is determined by the guideline for local values; that way, red is equivalent to a gray that is darker than the one used to represent yellow.

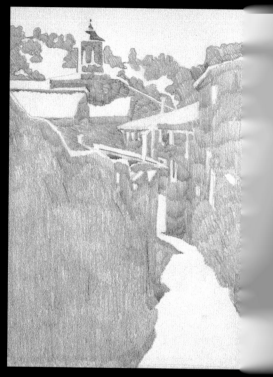

We can summarize a rural landscape such as this one—a narrow street illuminated from the side by intense sunlight— using a single tone of shadow in a type of modeling.

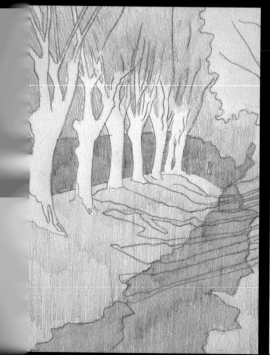

A grove of trees near a brook is drawn using the guideline of local values: every tone in the

The guideline of local colors distinguishes the main tonal contrasts; the black of the hair

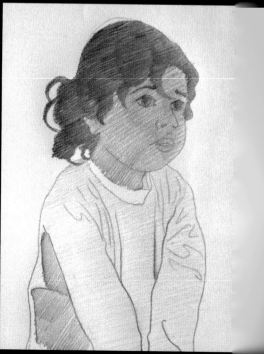

In accordance with the guideline of local colors, the local color of every area in a monochromatic

GUIDELINES FOR SHADING. Some simple guidelines can help us distinguish the tonal variations and the arrangement of shading on the model. A combination of both representations affords an appropriate tonal resolution of the model.

THE SHADING GUIDELINE. Shadows are likewise subject to a guideline. To recreate the shape and three-dimensionality of the model depicted, it's essential under certain light conditions to use the shadow guideline. This is based on the differentiation of the illuminated areas from the shaded ones in the model.

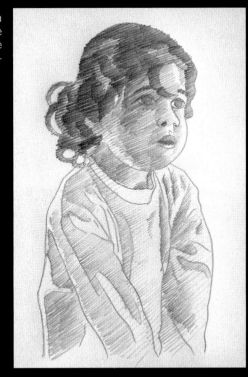

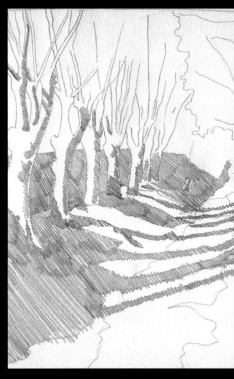

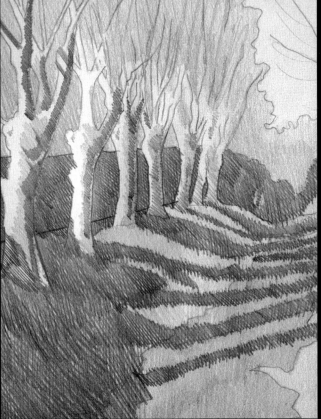

In a drawing based on the shadow guideline we are interested mainly in the distinction between the illuminated and the shaded areas.

The same grove of trees as before is now developed exclusively in accordance with the shadow guideline. The contrast between light and dark areas makes it possible to comprehend the model.

A COMPLETE GUIDELINE OF VALUES. A combination of the guideline of local values and the shadow guideline creates a complete guideline of values. When the light is intense, these two areas seem to have the same value and blend with each other. When the light is more diffuse, the shadow guideline diminishes, and the guideline of local values takes on greater importance.

By combining the guideline of local values and the shadow guideline, we create a complete tonal representation of the theme.

Shading with the stick held flat is fundamental to this type of work with charcoal. That's how we quickly darken the surface of the paper.

Let's analyze the method for drawing a tree trunk using charcoal and a model slightly more complicated than the one in the drawing. We first use the charcoal stick held on its side to darken the background and the shaded side of the trunk. Then we use the tip of the stick to apply some irregular strokes to the shaded area to represent the texture.

To create the homogeneous gray for the background of the landscape, the first shading with the stick of charcoal held flat is blended by simply passing the hand over it. That way we avoid the granular texture produced by moving the stick in a longitudinal direction.

To depict the foliage, we cut the charcoal stick into inch-long (2.5 cm) pieces and create dark, short, superimposed areas of shading, which we immediately blend using the tips of our fingers.

SHADING WITH CHARCOAL. Because it's easy to erase, malleable, and easy to modify by creating gradations or stumping, charcoal is the perfect instrument for doing quick landscape sketches. The treatment is not highly refined, but it's quick, efficient, and spontaneous.

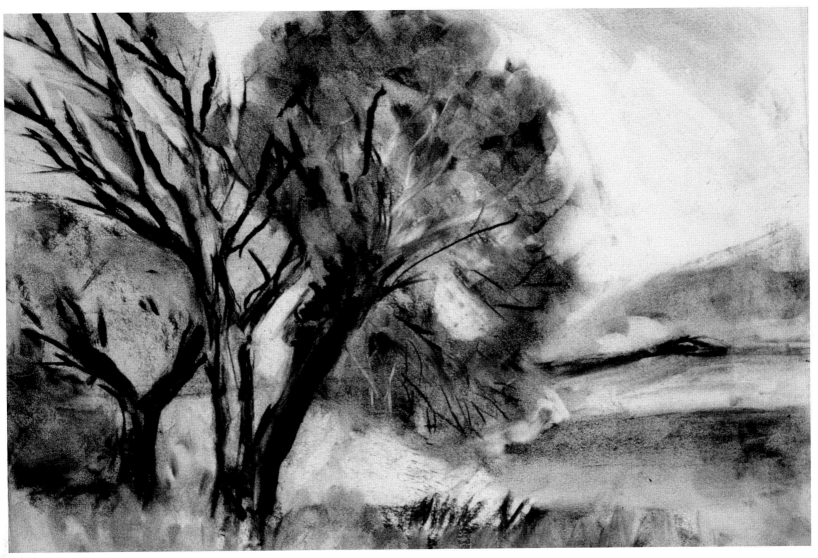

Shading with charcoal makes it possible to darken every plane in the drawing quickly and create a very expressive drawing with an attractive finish.

The effect of texture in the leaves of the trees is produced with an eraser, by opening up areas in the crown of the tree to simulate fine branches that give the overall picture greater texture.

COMBINING LINE AND SHADOW. There's no need to limit ourselves to shading, since lines can give more expressiveness and concreteness to the drawing. Shading contributes to highlighting the shape of the trunk and making the tree stand out from the background, and lines consolidate the profiles and provide texture and detail in the foreground.

7.1

VERY FAINT LINE. Using a soft, imprecise stroke and short, very diffuse shading, we draw the olive tree, which appears very soft on the surface of the paper.

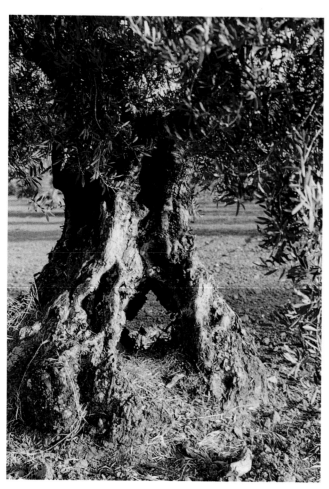

With just a few zigzag lines produced after several attempts, we sketch the outer profile of the olive tree. The shaded areas begin to appear indistinctly, without too much conviction.

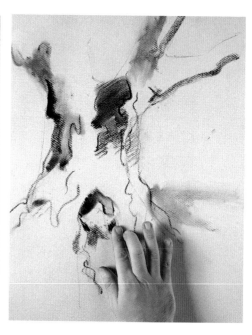

Working with the fingers is essential in stumping the shaded areas and blurring the lines where it's appropriate for the outline to be more diffuse. We sketch the position of the branches using a small stick of charcoal held on its side.

The first strokes are applied very gently, by practically caressing the surface of the paper with the charcoal to facilitate correction if needed.

7.2

SHADING AND ERASING. We construct the shape of the trunk by modeling the surface with shading and erasing. By alternating light and dark areas, we represent the irregular bark, complete with clearly differentiated projections and depressions.

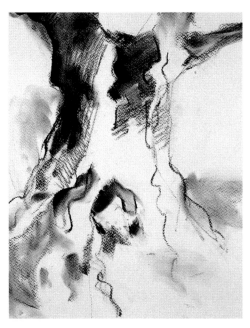

Using charcoal applied to our fingers, we add small touches of light gray at the base of the trunk. We set up the difference between the shaded side and the hollow using a darker gray, which we blend using our hand.

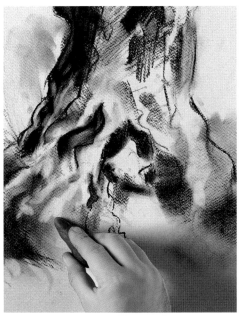

We contrast each fissure with lines and new shaded areas, which we likewise blend. At the top of the trunk the first shading in the form of hatching begins to emerge.

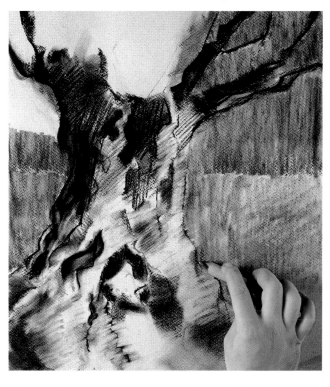

We apply the eraser to the hatching on the right side of the trunk. We finish the olive tree by projecting the branches with thick, dark lines. We cover the background with more shading and shade it off using vertical strokes with a blending stump.

We draw the branches by dragging the side of a charcoal stick to create a fine, very straight line.

7.3

HATCHING AND SCRIBBLING. In this final phase of the drawing we focus on the textures of each surface. To simulate the foliage easily, we use shading with hatching and a random series of lines or scribbles.

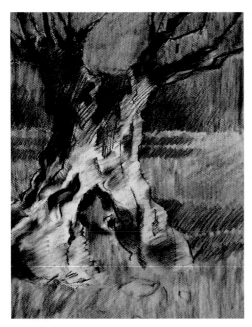

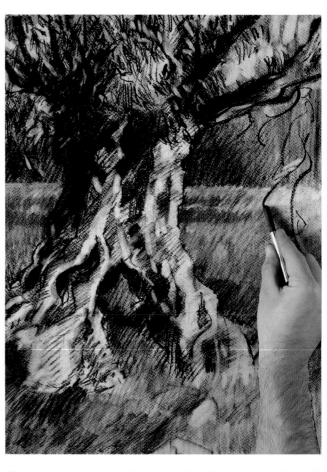

We complete the shading in the background. We resolve the upper edge using a medium gray and the sandy ground with a lighter gray. We slightly intensify the shading around the trunk with subtle strokes to increase the contrast.

We work on the relief of the tree bark by applying shaded areas in the form of hatching. Before adding the foliage, we open up areas in the sky and lighten the trunk with an eraser.

We darken the background using new hatching made up of diagonal lines. By combining the charcoal and a Conté crayon, we represent the series of branches and leaves with random, scribbled lines.

In this last phase, the Conté crayon is essential, because it permits darker lines than charcoal does, and it's a good choice for accentuating the outlines and darkening the shadows.

To highlight the shape of the irregularities on the trunk, we heighten the effect of chiaroscuro by clearly differentiating the tonal areas with pronounced contrasts.

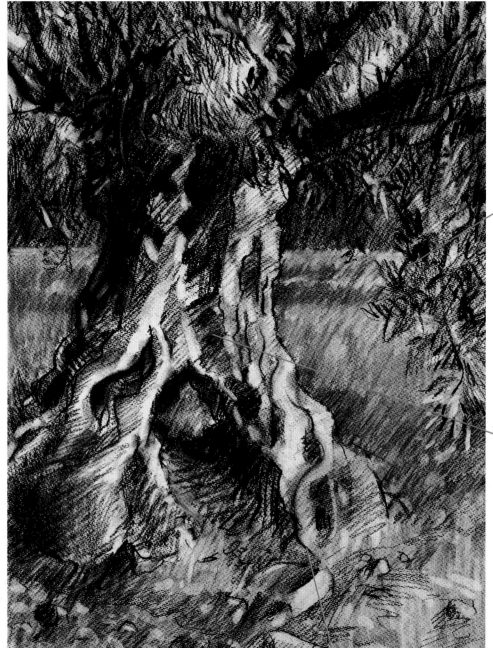

The scribbled lines of the leaves are clearly distinguishable from the blended background. There is a contrast between the lines and the tonal surface that keeps the planes from blending in with one another.

The trunk requires the strongest contrasts. We produce a pronounced shape by using the chiaroscuro effect and effecting abrupt transitions between illuminated and shaded areas.

We finish the foliage with a branch or a cluster of leaves that stand out on the scribbled surface. Then we add a bit of relief to the stony ground at the bottom of the drawing. The finish is very expressive. The branches, the strokes, and the intentional exaggeration of the twists in the bark produce a very dynamic effect. Drawing by Gabriel Martín.

The stones in the foreground are depicted by marking the edges or outlines with soft strokes, and by differentiating the illuminated faces with erasing and shading.

SHADING WITH THE HANDS. Lines are not the only way to shade. We can also use charcoal, chalk, and powdered sanguine. However, the powder doesn't stick to the paper by itself. It has to be pressed in with a piece of cotton or the hands, the artist's natural tools.

8.1

THE HAND AS A TOOL. The first phases of shading are done using a piece of cotton cloth and rubbing with the tips of the fingers, covered with pigment, using broad, quick movements.

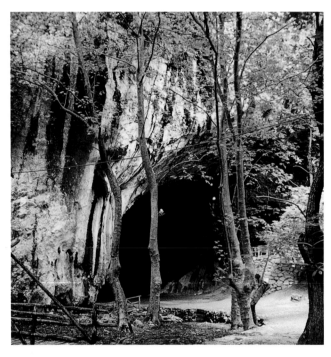

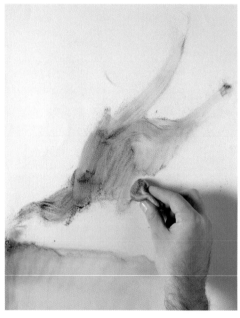

We load a piece of cotton with sanguine powder and color in the darkest areas of the model: the forest floor in the foreground and the cave. After applying the color, we blow on it or tap the easel to remove the loose pigment.

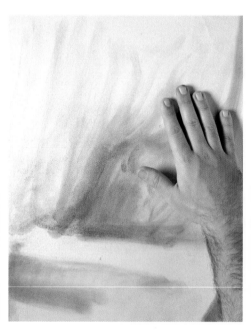

Using the tips of our fingers, we apply more pigment to the paper. We model the veined surface of the rocky wall using a few passes with the hand held open. Using the thumb covered with color, we darken the outline of the cave.

To draw the tree trunks, we cover the tips of the index and ring fingers with plenty of pigment and rub it firmly onto the paper.

We use one finger or the other, depending on the thickness of the trunk or the branch being drawn.

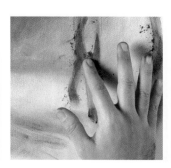

8.2

LINES AND TEXTURES. In this second phase, we incorporate finer lines and effects of texture that provide the drawing with additional information. This treatment is applied by combining modeling with the hands, blending, and erasing.

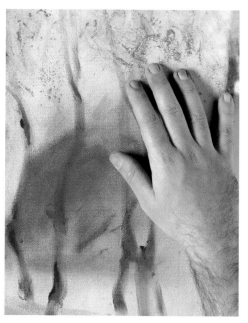

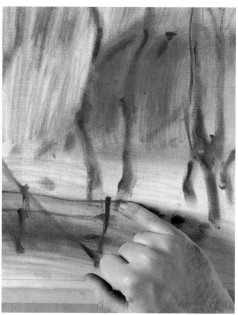

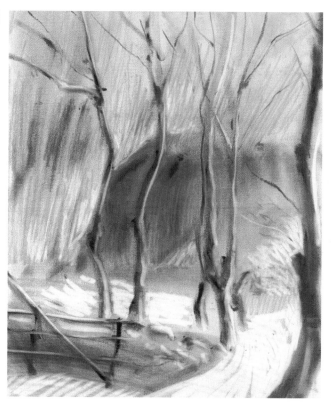

To give the foliage a warmer tone, we use our hands to apply a little ochre pigment to the tops of the trees. We spread the color out in an irregular manner with our hands, moving the fingers like a pianist.

Using the tip of a medium stump and the little finger, we draw the branches on the trees and the wooden fence rails at the bottom. We gradually reduce the pressure in drawing the branches to make the lines vanish.

We use the eraser for the final effects of texture: We open up light areas in the road, draw a light line on the tree trunks, and apply a series of vertical lines on the rock wall.

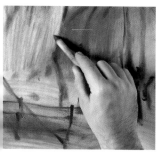

We use the point of the blending stump coated with pigment to draw the thinnest branches that we can't trace with our fingers.

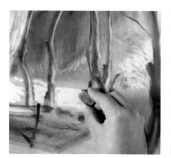

Using the eraser, we open up light areas to accentuate the illuminated areas, and we apply lines that create texture.

LEONARDO'S SPHERE. Leonardo da Vinci studied and theorized about the imprecise outlines of shadows. He observed that the shadow cast by a sphere illuminated by the light from a window exhibited a gradation that made it impossible to determine its outline precisely. To resolve this question, he invented the well-known *sfumato*, an innovative process intended to avoid clear outlines of objects and shadows.

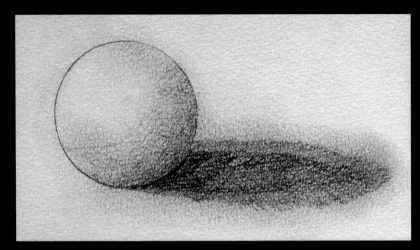

TOOLS FOR SFUMATO. The fingers or a blending stump can be used to create sfumato, but the two systems produce quite different results. The fingers allow greater control over the gradation because of the direct contact with the paper. However, the stump creates a more subtle and homogeneous gradation, its tip allows for greater control, and the finishes and edges of the shaded areas are much more meticulous and precise.

Leonardo's principle is based on the impossibility of determining the outline of the shadow cast by a sphere illuminated by diffuse light.

SFUMATO. *Sfumato* refers to a drawing with a misty, atmospheric appearance, with no clearly defined borders, where objects are depicted as blurry spots with no outlines, but with very subtle tonal gradations and soft shading.

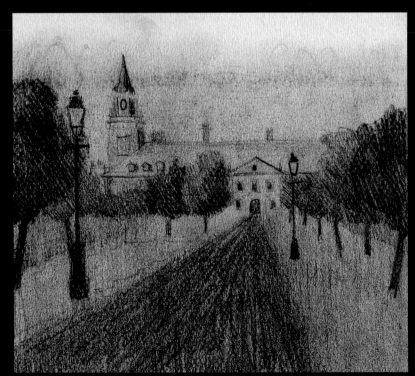

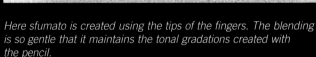

Here sfumato is created using the tips of the fingers. The blending is so gentle that it maintains the tonal gradations created with the pencil.

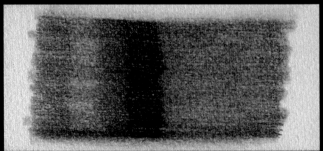

Sfumato is appropriate for creating landscapes with a foggy or mysterious appearance.

Here sfumato is done with a blending stump. It substantially obscures the gray done in pencil and equalizes the various tones.

DIFFUSE SHADING. Light that bounces or is reflected or filtered by a translucent body reaches the model in a filtered condition. This is what happens with clouds in a landscape, or with a curtain indoors. Thus, the shading must be diffuse, and the contrasts subdued. In these cases, the shadows appear softer and look like dark, indefinite halos that appear softly beneath the shapes. In addition, there is a major transition between the most highly illuminated parts and the shaded ones, producing a rich set of intermediate tones.

STUMPING. Stumping involves spreading out and removing color with the intent to diminish intensity. Stumping makes it easy to create three-dimensionality, but if we go overboard with it, the drawing can turn out murky, and lacking in precision and definition. To avoid that, it's best to have a clear idea of the values, the light and dark areas, and the contrasts between them.

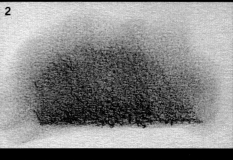

There are different types of stumping, and each one produces different textures or effects with graphite: (1) shading with graphite; (2) shading with the fingers; (3) using a blending stump; and (4) using an eraser.

DIRECTION OF STUMPING. The strokes with the blending stump can be straight or curved, depending on the model. For example, to represent the shape of a figure's muscle or arm, curved and straight lines are used alternately; for the buttocks, the strokes are circular.

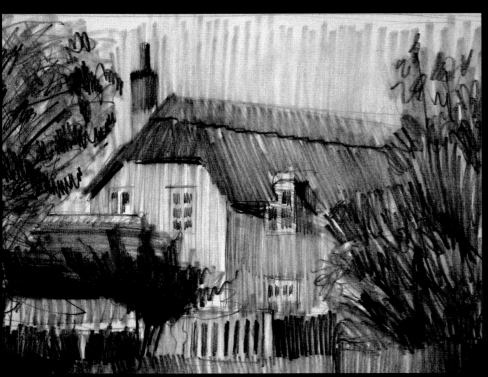
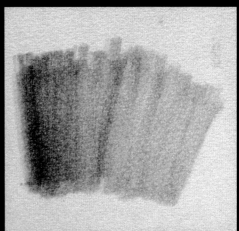

When we wish to control the direction of the stumping, we use the blending stump, which is the only instrument that allows stumping and the creation of lines at the same time.

Whenever we work with stumping, we need to be attentive to the direction of the strokes. Here they are perpendicular in the sky, diagonal on the roof, and random in the vegetation.

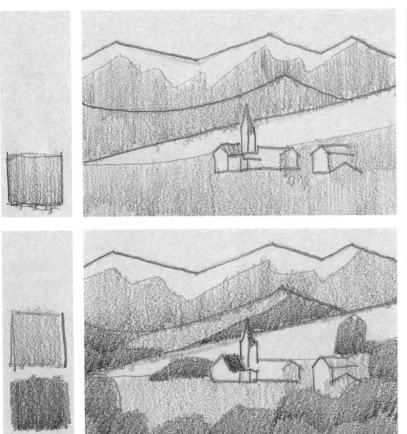

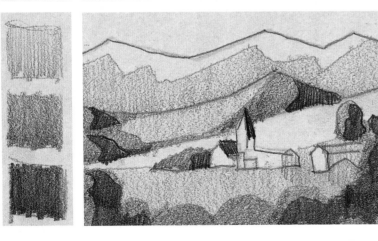

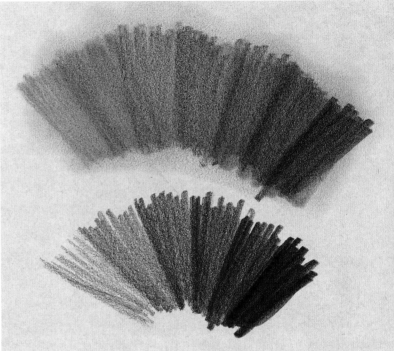

Making use of stumping is essential if we intend to draw an atmospheric landscape in graphite tones. Compare the two tonal scales: In the upper one, which exhibits stumping, the presence of the strokes has nearly disappeared, and the tones appear in diminished contrast and with more integrated edges.

The smooth tonal transitions in the drawing are produced by rubbing with a piece of cotton. It's best to avoid working with the blending stump in this case, for this implement clumps the graphite together more and leaves marks on the surface.

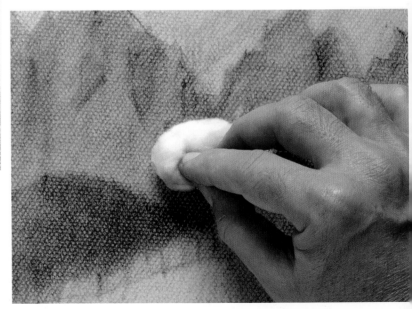

The tonal representation of this landscape depends on the process used. These three sketches explain the best development for doing the drawing, with progressive addition of tones. The first application corresponds to a light gray tone, setting aside the color of the paper for the lightest areas on the mountains. The second instance incorporates a medium tone that highlights the effect of three-dimensionality. We finish up with a dark gray that highlights the contrasts between the planes.

LANDSCAPE WITH SFUMATO. Sfumato has the effect of softening the shading. This technique makes it possible to mix the tones easily and help produce very subtle tonal gradations, such as misty effects, for the purpose of depicting shapes without drawing outlines or profiles. For sfumato it is common to use a graphite pencil because it's easy to blend and smudge, and offers rich tonal qualities.

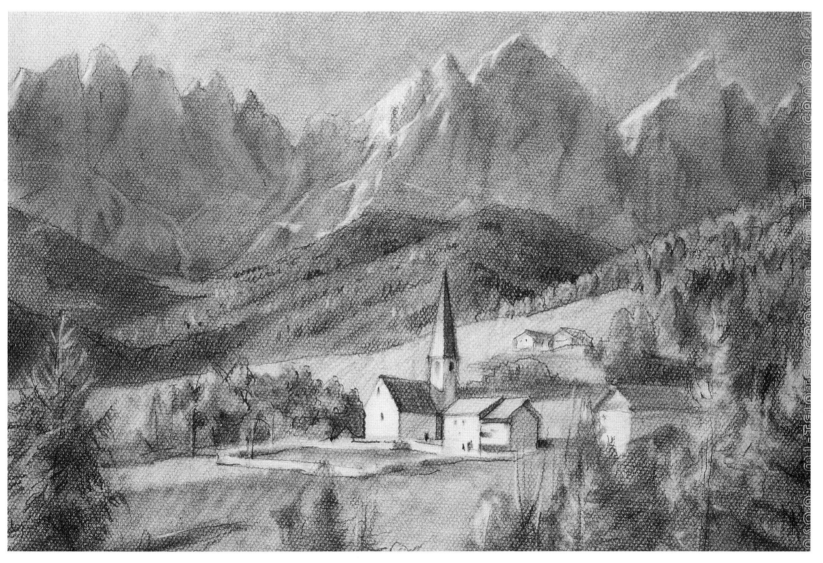

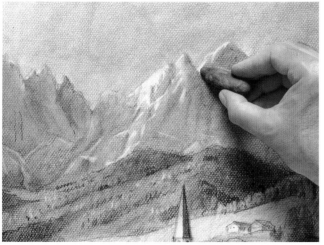

In this mountain landscape done in graphite pencils, we see a very atmospheric treatment because of the stumping effect, which involves softening the lines and contrasts among the shadows by rubbing with the hand, a stump, or a piece of cotton.

Despite the continuous blending, the drawing presents interesting three-dimensional effects created through contrast. The artist has produced this effect by opening up light areas with an eraser, thereby creating greater contrast between the illuminated and the shaded areas.

Shading
Techniques

In general terms, shading is a transition from light to dark tones, and vice versa. Although there are many different shading techniques, nearly as many as there are artists, some are considered more appropriate than others for certain works. But in all of them, the main issue is the values of light and shadow. The choice of one technique or another depends on the plastic effect we wish to create and the medium we are using for the drawing. In this section we will consider the possibilities of each of the drawing processes in creating the shading.

MODELING. Modeling involves depicting a subject by shading it with smooth tonal transitions, without leaving visible strokes or lines. The shadows appear represented by gradations, with no abrupt contrast between tones. In this exercise we will study how to shade and model the different areas of a drawing. We will skip over the layout and drawing steps and go directly to the shading.

9.1

SHADING WITH A STICK OF CONTÉ HELD ON ITS SIDE. Before starting to model, we have to shade. The best way to shade a drawing is to work with the stick of sanguine held lengthwise. That makes it possible to cover the drawing quickly, develop gradations with greater ease, and avoid visible strokes, which would be too apparent if we were working with the tip of the stick.

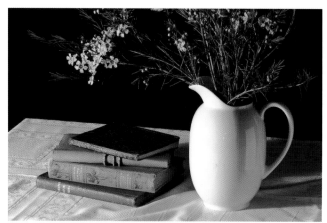

Working with the side of the stick of sanguine, taking care to avoid the area occupied by the flowers, we cover the background with a broad shading in gradation. Then we shade the covers of the books very evenly, setting aside in white the illuminated areas.

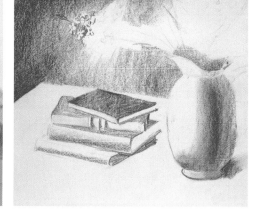

In shading the pitcher, we have to proceed very carefully, because its shape is a bit more complex. We define the pitcher with gradated shading that runs from top to bottom.

The preliminary sketch for the drawing is customarily done using a graphite pencil with very light pressure.

The graphite keeps the powder from the sanguine from adhering to the paper, so after producing a convincing drawing of the model, we lightly erase the lines. The lines that remain must be very light, just enough to guide us in the shading.

9.2

MODELING TO CREATE THREE-DIMENSIONALITY. The effect of three-dimensionality is produced by modeling the surface of every object in smooth transitions of tone; thus, the shadows that are incorporated and exhibit pronounced gradations need to be softened with the tips of the fingers.

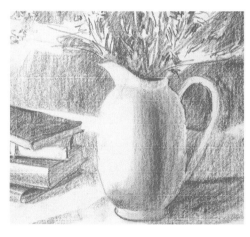

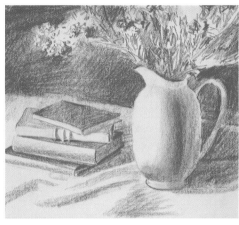

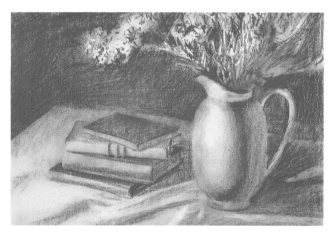

We resolve the flowers using excited, imprecise strokes with the tip of the stick. It's not necessary to draw them stem by stem, but rather to recreate the whole. By once again using the side of the stick, we add the shadows cast by the pitcher, taking care to differentiate the shadow and the half-light with two different tones.

The modeling is very smooth and gradual, with no visible strokes. This is achieved by intensifying the values with new soft shading and blending to create gradations with the tips of the fingers.

If we have done a proper assessment of the subject, we succeed in modeling the shapes, which appear in all their relief and three-dimensionality. With this type of modeling, the artist simulates in two dimensions what the sculptor does in three: giving body and presence to the subject. Drawing by Óscar Sanchís.

It's a good idea to practice in advance and on a separate piece of paper by modeling with sanguine and creating gradations with the fingers.

VOLUME THROUGH CHIAROSCURO. Now we address a subject with pronounced contrasts between light and dark using the chiaroscuro technique. The shadows created with charcoal are dense and dark. We achieve the effect of modeling almost exclusively with our hands by rubbing, shading, and lightening, thus modeling the shape of the column using contrasts between the light and the shaded areas.

10.1

LIMITED STROKES. We locate the main lines in a quick drawing that uses the smallest possible number of strokes, which we vary in intensity according to their importance. We don't seek a precise rendition of the model. The particular framing of the subject allows the artist to highlight a certain distortion or exaggerate the appearance of recession in the column.

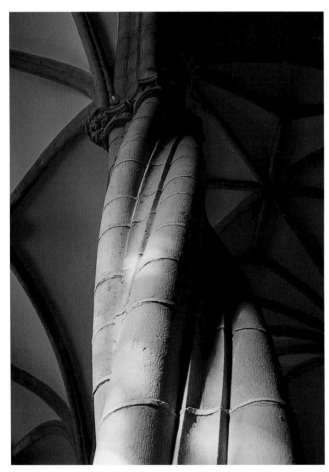

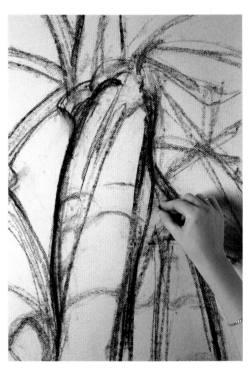

Using the stick of charcoal held flat, we use diagonal strokes to lay out the spiral shape of the column in a very synthetic way. The fewer lines or colored areas we lay out, the less we have to adjust.

As we progress in the layout, we use the tip of the stick to darken the outline of the column. This allows us to reinforce the main lines.

To make it easier to draw with the side of the stick, we cut the charcoal into shorter pieces.

To create the effect of perspective, we make the column narrower as it gains height.

MATERIALS FOR EXERCISE 10: Conté crayon, charcoal stick, cotton cloth, blending stump, kneaded eraser

10.2

QUICK SHADING. We quickly darken the background using the side of the charcoal stick to distinguish and isolate the main shapes. Although this produces a soiled appearance, it makes it possible to develop an initial scale of medium tones, which is necessary for the subsequent application of new shadows that produce an effect of chiaroscuro.

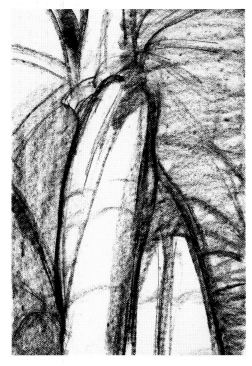

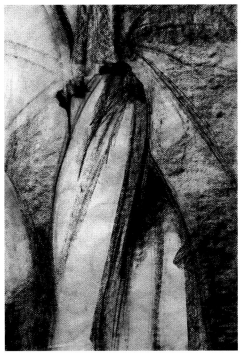

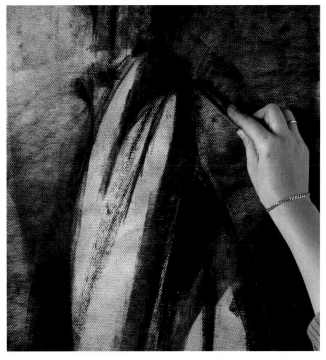

First of all, to differentiate between the light area of the column and the darkness of the arch, we apply an initial shading on the background and extend it to the right-hand side of the column, which also remains in shadow.

We effect an overall blending with the hand held flat on the shading so that it is incorporated more effectively into the paper. Then we shade with darker black, using lots of pressure on the side of the charcoal stick.

We contrast the areas of light and shadow on the column by using the tip of the charcoal, and we even out every new addition of gray with the tips of our fingers. The shadows appear clearly differentiated because of their outlines.

If we smudge the charcoal with the tips of our fingers, we produce the perfect base tone for the stone in the ceiling.

The background is resolved with a simple tonal gradation, which runs from the darkest black at the bottom to a gentle gray at the top.

10.3

CHIAROSCURO WITH THE HANDS. So far we have worked only on the basic shading to differentiate the areas of light and shadow. As we progressively add the effect of chiaroscuro, we will study which of the blacks will be the darkest we can achieve. In modeling we use mainly the hands to form gradations in the shadow and to lighten it, because the hands produce good results in the areas of strong and medium illumination.

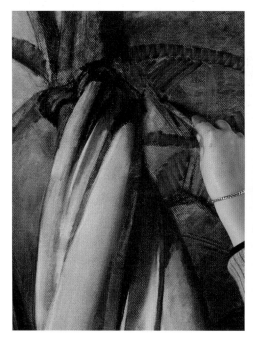

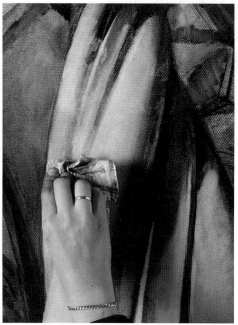

Using a stump loaded with charcoal, we sketch the arches of the Gothic nave. To stand out, the lines have to be darker than the preexisting gray without becoming absolutely black, which is reserved for the darkest areas in the background and the column.

To create the effect of smoothness on the stones of the column, we need to use a cotton cloth. We use it to rub the pillars from top to bottom, lightening the shadows and softening the gradation.

The right-hand section of the background displays a darker overall tone than the left. We also darken the right-hand section of each pillar to create an impression of volume. We use the eraser to simulate the joints between the stone blocks.

To create a convincing chiaroscuro, it's appropriate to lighten the areas of greatest illumination with a kneaded eraser. The greater the contrast between light and dark, the more pronounced the impression of volume.

Using the tip of the charcoal stick, we bring the shaded area of the column to near-total blackness.

Using the kneaded eraser as if it were a pencil, we open up light lines that give shape to the capitals.

Once we have achieved the effect of chiaroscuro, we use our fingers to blend the grays of the background. Now we set aside the stick of charcoal and use a Conté crayon, which makes it possible to create more intense blacks. We outline the columns so that they stand out clearly against the background. Drawing by Mercedes Gaspar.

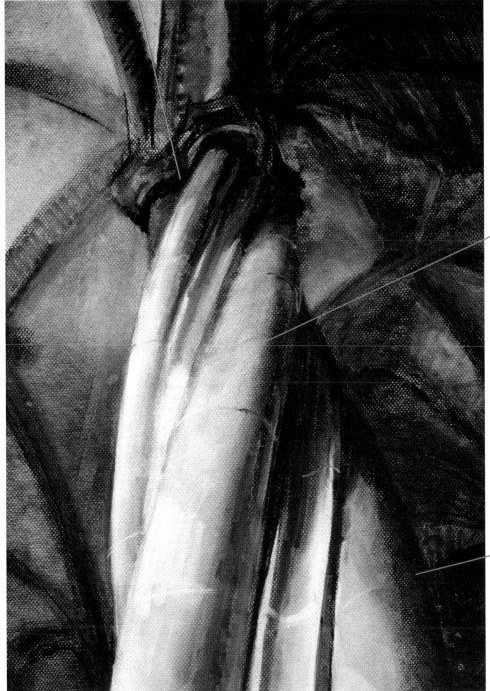

Using a gradation from intense black to light gray, we achieve the three-dimensional effect of the cylindrical columns.

We locate the absolute black along the right-hand edge of the column. The gradation in the background next to this outline is slightly lighter to highlight the feature in the foreground.

GRADATIONS USING CHARCOAL OR CHALK. It's easy to create gradations with charcoal or chalk by using the side of the stick and increasing or decreasing the pressure on the paper.

Gradation using a stick of charcoal.

Gradation using a stick of chalk.

DEEP GRADATIONS. A gradation done in chalk or sanguine takes on depth if we rub the surface of the paper with a blending stump, because the powder penetrates into the pores of the paper and the color darkens.

Gradation done with a stick of chalk and gone over with a stump.

GRADATIONS USING A PENCIL. Gradations in pencil are commonly done by alternating pencils of different hardness. However, a pencil can be used to create a gradation in traditional shading done in parallel strokes by simply reducing the pressure exerted on the paper. When doing gradations in pencil, it's important that the point be fairly dull.

Gradation done with a graphite pencil.

Gradation done with a blue pencil.

MASTERING GRADATION. Gradation is shading that provides a smooth transition from one tone to another so that all the tonal values of a particular scale are represented in order and without visible breaks.

ATMOSPHERIC GRADATION. We can avoid the presence of graphite pencil strokes in the gradation by working with the side of the tip, drawing small circles in smooth, rotating motions. The effect of this type of gradation is more foggy, atmospheric, and delicate than the classic one using parallel strokes.

The presence of pencil strokes is nearly imperceptible in an atmospheric gradation.

VOLUMETRIC EFFECT. The gradation is adjusted to the effect of the light on cylindrical and spherical shapes, so it is the most commonly used resource for giving shape to these types of objects.

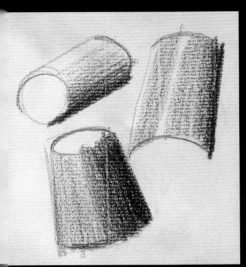

The representation of a cylindrical model takes on volume with a simple gradation.

DRAWING WITH GRADATIONS. We can do drawings using nothing more than gradations, which contribute to emphasizing the effect of volume. The result is very interesting, although the distribution of the light and shadow is a little disconcerting and ambiguous.

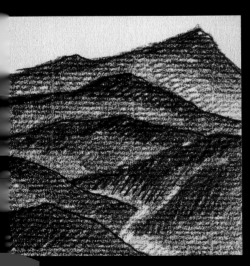

When applied to landscape, gradation highlights the voluptuousness of the different planes.

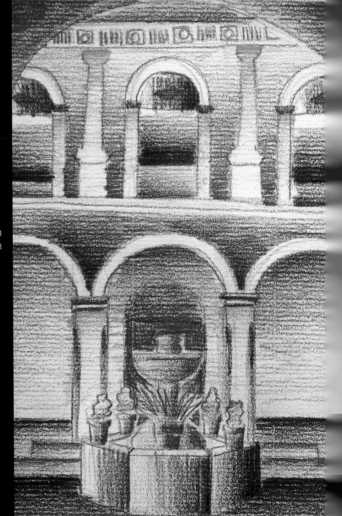

HATCHING AS SHADOW. Using hatching to create shadows is an effect that can be used to create various tones and values by spreading out a type of "carpet" of superimposed pencil lines that often cross one another at an angle.

11.1

A SOLID DRAWING. We have to exercise considerable care in doing the drawing, because it will be the basis for all the subsequent hatching. It must be bold, linear, and confident, with lines that delineate the shaded and illuminated areas. The final result depends in great measure on the initial drawing.

Using a sharpened black chalk pencil, we use lines to synthesize the outline of the rocks. The inner lines, which are also synthetic, highlight the relief of the rock and separate the illuminated areas from the shaded ones.

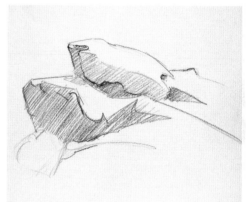

In a very general way, we distinguish the main areas of shadow in the rocky formation by applying an initial hatching in a classical shading consisting of parallel lines. As the hatching is applied, some outlines in the rock are highlighted.

The first shading is done using a simple or traditional hatching, a series of diagonal, parallel lines that present an even shading.

To keep the shading even, the superimposed hatching must be applied at an angle that is different from the first one.

11.2

SHADING WITH HATCHING. It takes time and patience to do drawings with hatching. This technique of shading makes it possible to calculate precisely the value of every light and shadow. It is very important, and perfect mastery is proof that the artist is well trained.

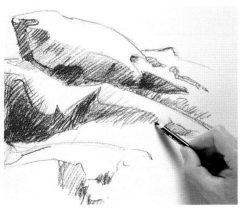

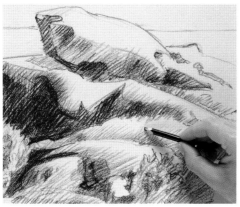

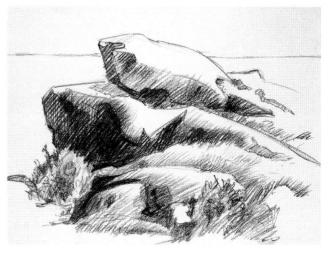

We superimpose the first hatching onto the previous layout in gray to darken the shadows. The darker we want the shadows, the more we bear down with the pencil.

We spread out the intermediate tones using very light strokes. We superimpose a third hatching onto the darkest shadows on the rock. We leave white the areas of maximum light.

The combination of multiple hatchings produces works with rich tonal values that suggest the quality of the surfaces depicted. In contrast to works done using gradations in pencil, the shadows of a drawing that incorporates hatching exhibit a greater effect of texture. The superimposition of lines endows the drawing with much more visual information and more detail than in reality. Drawing by Óscar Sanchís.

Experimenting with hatching can be interesting. We can impose different types of hatching onto a conventional pattern, varying the line and the pressure exerted with the pencil in each one. This produces a variation in the darkness and the texture of the resulting shading.

Hatching is not only a special method of shading, but also produces an effect of texture.

CLASSICAL SHADING. Classical shading was developed in the fifteenth and sixteenth centuries by the great artists of the Italian Renaissance. This technique involves drawing a series of parallel lines at about a 45-degree angle to cover the whole area to be shaded. The closer together the lines are, the darker the shadow.

An example of classical shading.

HATCHING. Hatching involves juxtaposing and superimposing lines. Because of their uneven nature, they can produce a sensation of vibrations when seen at a moderate distance, and that doesn't happen in areas filled with flat color. It's worth experimenting with all the possible types of hatching, using different media, colors, and lines.

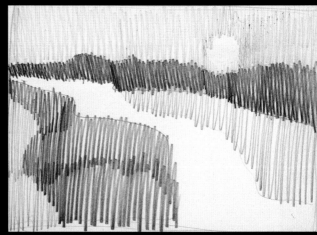

Landscape sketch using classical shading.

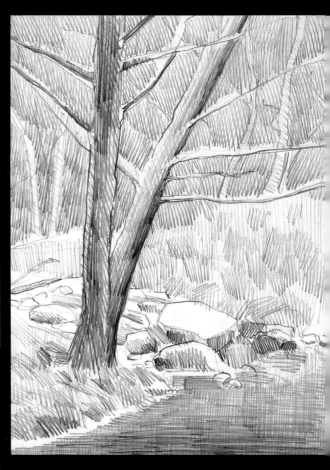

Different types of crosshatching can be produced by varying the angle of intersection and the intensity of the lines.

CROSSHATCHING. In classical crosshatching, the lines cross at a slightly different angle. These angles, which are nearly the same, create a moiré design that makes the shading somewhat luminous because of the spaces through which the white of the paper breathes. Increasing the angle of the intersecting lines creates a different type of crosshatching, and more white space is opened up. In both cases, it is

A landscape sketch done by combining several types

TYPES OF SHADING. There are different techniques for shading. The choice depends on the plastic effect we seek and the medium in which we are working. Let's look at a few of the most common shading techniques used by experienced artists.

LINES. This involves classical lines in which we vary the pressure and the width of the line to indicate different tonal areas. Applied decisively, lines can give sketches great force.

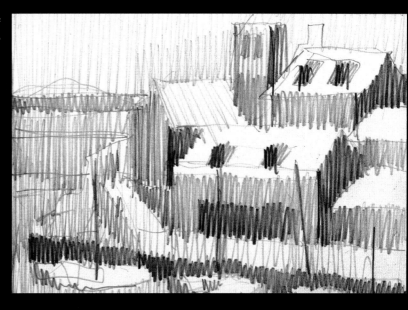

Application of lines to a drawing.

SHORTHAND SHADING. This relates the structure of the shadow to the expressiveness of the line, linking the type of lines to the calligraphy appropriate to writing. The use of lines facilitates gestural expression to a greater extent than when drawing outlines. This shading doesn't allow for a very precise and detailed treatment; only the specific features that define the shapes are represented.

MODELING. When we manipulate a 4B pencil very smoothly, the direction, the tone, and the shape of the pencil strokes are softened. The tonal transitions between the areas of light and shadow are resolved gently. We reserve lines for indicating textures on the objects.

Still life done with shorthand shading.

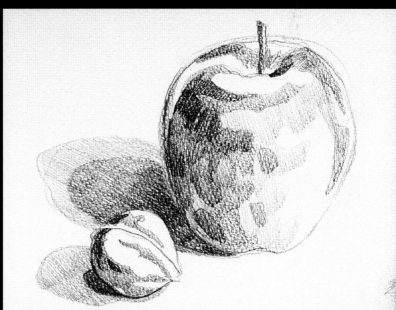

We depict the shape of the objects with smooth tonal transitions that are either blended or gradated. In modeling we must avoid abrupt contrasts in tone.

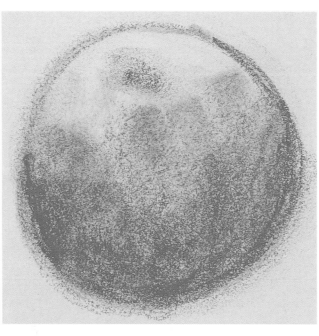

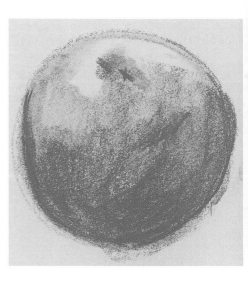

Let's see in this progression how to depict a piece of fruit to make it look like the model. We first color the shaded area using the stick of sanguine held flat.

After blending the previous addition with the tips of the fingers, we apply more shading at the bottom of the sphere and indicate the depression at the top of the apple.

We use the tip of the stick to darken the lower half and outline the roundness of the apple with a dark line. The effect of the representation owes much of its success to the gradation that covers the surface of the object.

The use of the blending stump is the key to creating a convincing effect in the objects included in the composition. When its point is loaded with color, we can create smooth gradations simply by dragging it across the paper.

The background of the composition must appear very sinuous; the shapes nearly disappear and become integrated with the white of the paper. This is achieved with a few fine lines that are blended using the stump.

MODELING WITH SANGUINE. Sanguine is a medium with lots of coloring power. The stroke is smooth, and it facilitates modeling, giving the drawing a rich gamut of medium tones. The modeling effect in this still life is done by controlling the gradation, diminishing the presence of lines, and with an atmospheric blending that avoids stark tonal contrasts.

In works such as this one it's appropriate to use a restrained scale of tones. These four tones, to which we add the white of the paper, are more than sufficient.

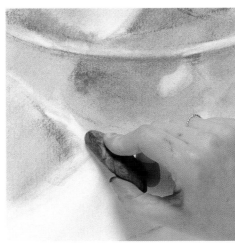

Concentrate on the light areas. As always in such cases, they are created by erasing with a kneaded eraser. Erasing is very useful for restoring the white in an object and expanding the gradation in the drawing.

The effect of depicting the shadows and the general blending produce a light drawing with correct intonation and with scarcely any abrupt changes in the transition from the illuminated areas to the shaded ones.

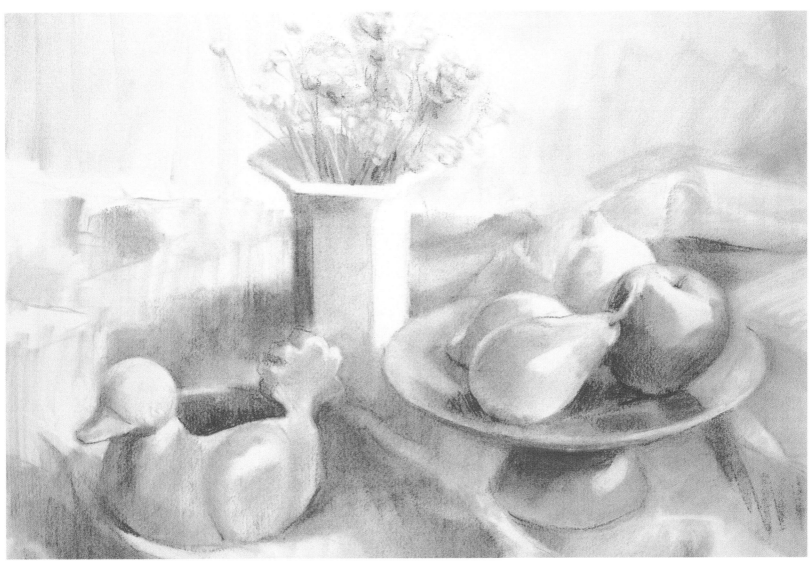

A DRAPE IN CHIAROSCURO. We now propose a study of a piece of fabric. In this exercise we will work with the shape of the folds through a detailed study of light and shadow. The shading technique we will use is chiaroscuro, which involves modulating the light on a background of shadow, thereby creating abrupt contrasts in tone to suggest the relief and depth of the folds in the drape.

12.1

ANALYZING THE FOLDS. Before starting, it's appropriate to study very carefully the shape of the folds. After studying them, we sketch the direction of each fold in a schematic way. This provides enough of the structure so that we can add the light and shadow to it.

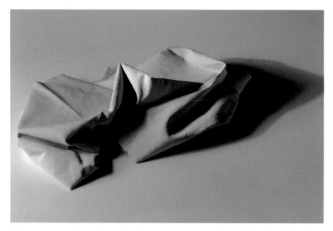

Using the tip of the charcoal stick, we very gently draw the overall shape of the cloth, the shadow projected onto the table, and the main folds.

Using the side of the charcoal stick, and without exerting much pressure, we give the whole drawing a general shading.

We must use short, straight, synthetic strokes to draw the folds of the fabric. They allow us to analyze the structure, and they indicate the direction that the cloth takes in each instance.

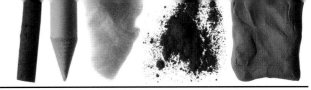

12.2

HEIGHTENING THE CONTRASTS. The second phase involves shading the drape with fairly uniform grays, preserving the illuminated areas so that the areas of light and shadow are clearly differentiated. It's not yet time to apply the intermediate tones.

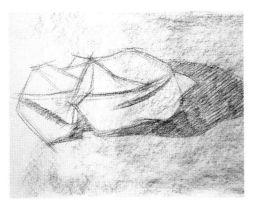

Using the tip of the charcoal stick we darken the lines that define the cloth, and we reinforce the main wrinkles. We use diagonal hatching to represent the shadow that the cloth casts on the table.

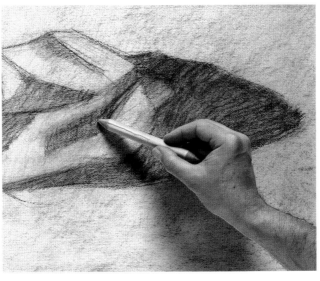

Using the stick of charcoal we add a light line to darken the shaded areas in the folds, and we leave the illuminated areas white. Then we use a blending stump on the lines so that the powder covers the paper better, and darken the initial shading.

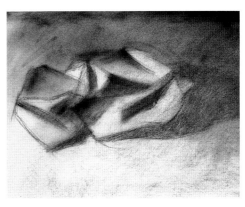

We attenuate the initial contrasts by going over the whole with a piece of cotton, until the shading is appropriate for the medium tones. We use the piece of cotton loaded with charcoal dust to darken the top part of the table so that there is a clear gradation from top to bottom.

We use a piece of cotton and powdered charcoal for the shading process. That way we avoid visible strokes and very gradually shade the flat surface of the table.

Charcoal covers more effectively than pencil, and makes it possible to incorporate more energetic shading. It offers a broad range of tones and allows spreading by blending and manipulating it with the fingers and the blending stump.

12.3

CHIAROSCURO EFFECT. In this second phase we gradually intensify the dark shadows with new additions of charcoal. The drawing takes on a surprising effect of three-dimensionality because of the contrast between these blacks and the white of the paper, which we preserve in the illuminated areas.

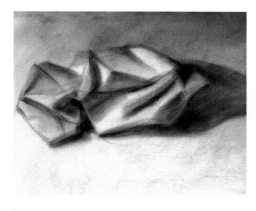

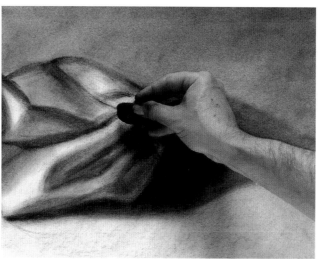

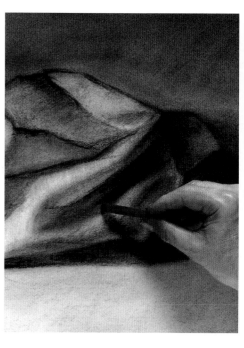

We begin the study of the folds by reinforcing the inside of each wrinkle with new, darker strokes. We darken the shadow so that it stands out from the overall shading of the table. In darkening this shadow, we give more definition to the right side of the cloth.

By combining the work with the tip of the charcoal stick and shading with a cloth pad, we finish applying the medium tones and the effect of gradation on the broadest folds. We work carefully, because we need to preserve the white in the illuminated areas of the folds.

The last strokes are the darkest ones. Using thick, dark black lines, we accentuate certain wrinkles and heighten the chiaroscuro in each fold with darker gradations.

To draw folds correctly, we illuminate the part that sticks up and shade the fold in a gradation that extends from the lightest part on the outside to the darkest on the inside.

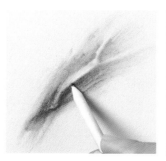

One alternative to the foregoing is to mark off the edges of the shadows and fill in each of them with grays or gradations.

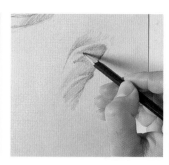

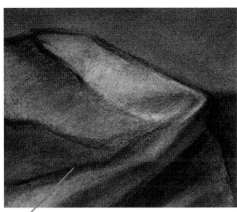

To keep the cloth from sticking to the background and blending with it, we go over the upper edge of the fabric with a thick, dark line.

We intensify the contrasts that establish the chiaroscuro effect on the various dark areas of the cloth. We also darken the large, dark shadow on the table. Drawing by Carlant.

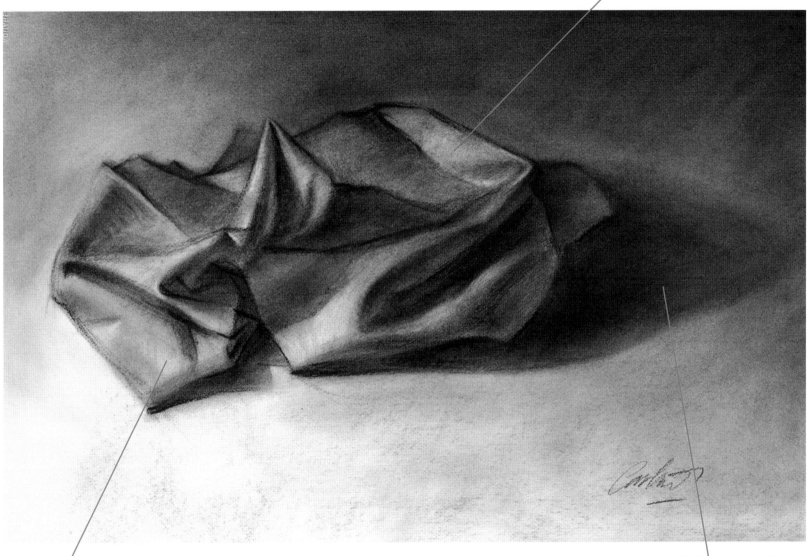

To reinforce the light areas, we restore the white of the paper by making some small erasures with a kneaded eraser.

It's appropriate to differentiate between two tones in the shadow: the dark tone that corresponds to the shadow, and the medium gray of the half-light.

A TENEBRIST STILL LIFE. Tenebrism plunges objects into an atmosphere with little light and surrounded by shadows, in a setting where shadow triumphs over light. Media that are considered unstable—charcoal, a Conté crayon, or black chalk—are ideal, because they offer little precision in outlines and help us approach things through a tactile approach, through doing and undoing, and through doubt.

13.1

SKETCH ON A TONAL BACKGROUND. The initial drawing needs to be precise and austere; the proportions must be adjusted and the shapes must be defined without devoting too much attention to the details. We have chosen a brown support because it's the color that dominates in most tenebrist themes, and that makes it easier to represent the intermediate tones.

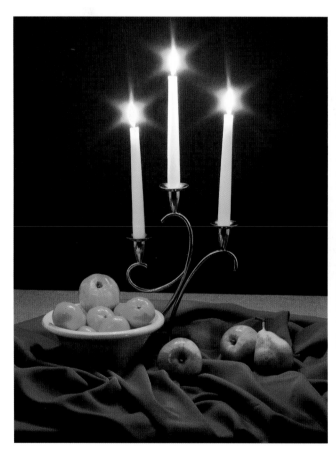

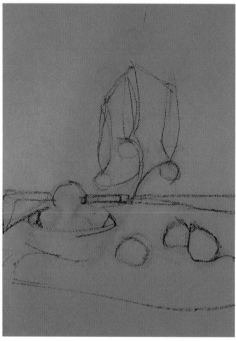

In this work, the layout is not as important as in others, because we cover it almost completely in shadow, which allows us to hide or correct errors in drawing. The initial shapes are sketched with the side of a charcoal stick.

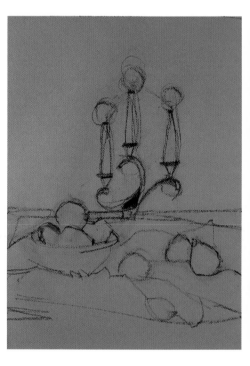

We affirm the main shapes of the still life using more precise lines: The fruits are simple circular shapes; the folds in the cloth, synthetic lines. The design of the candleholder requires a little more attention.

It's very useful to learn how to draw lines using the side of a charcoal stick, because with a simple turn of the wrist we can make fine, straight lines or broad, thick strokes.

13.2

THE CANDLELIGHT. The scene must be illuminated by the light source represented by the candles. This must be done in an effective and theatrical way, so that the contrast between the light from the candles and the rest of the work is dramatic. The medium tones are represented by the brown color of the paper, which we allow to breathe between the areas colored with charcoal.

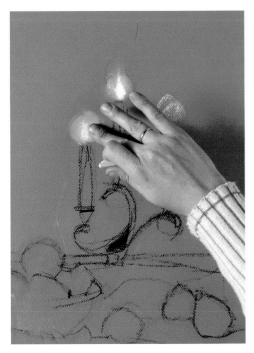

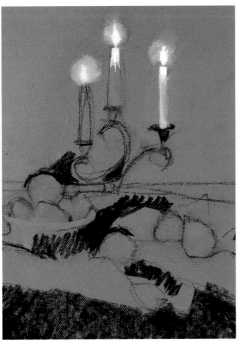

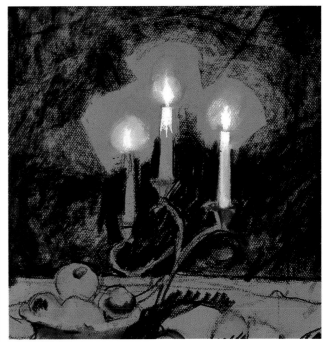

Using a stick of white pastel, we color in the flames of the candles with an intensity that covers completely. To depict the halo from the light, all we have to do is blend the initial white with circular motions.

In addressing the effect of the light, we color the upper part of the candles with new additions of white. Using the side of a charcoal stick and bearing down, we apply black evenly to darken the shadows in highest contrast on the tablecloth.

We cover the background in an intense black. We work with the side of the charcoal stick to cover the broad areas. We need to use greater precision in coloring the background around the shape of the candleholder, so we use the tip of the stick. We leave the halos of the candles brown.

The candle is resolved using a white gradation, which is lighter at the top near the flame and somewhat gradated, mixing with the color of the support as we move downward.

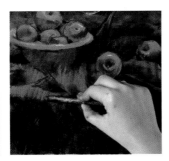

After the general coloring with the side of the charcoal stick, it's appropriate to darken the shadows, making them blacker and more opaque. For that purpose we pass the flat stump over the surface of the paper.

71

13.3

OBSCURITY AND DARKNESS. Now we proclaim the absence of light, the sensation of darkness. In so doing, we invade the surface of the paper with dense, large shadows. This dark mantle stimulates the sense of sight by blurring the familiar shapes of the objects and energizes them through dramatic contrasts.

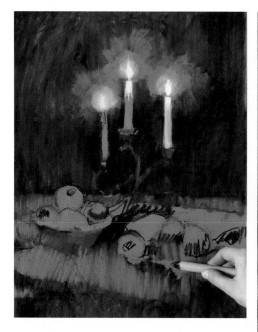

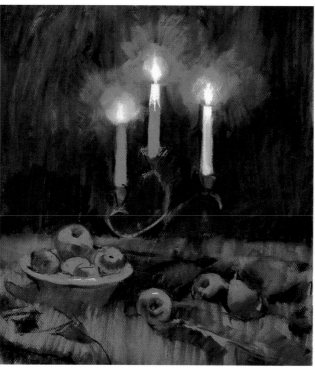

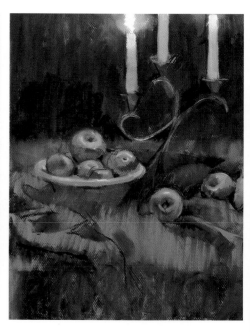

Using the tip of a thick blending stump held at a slight angle, we blend the black of the background until it turns into a darker, opaque shadow. We use strokes with the blending stump to close in on the halo of the candles, and we rub the stump on the light areas to give them texture and integrate the color of the paper into the whole.

We use light touches with the stump to darken the appropriate areas of each fruit, keeping in mind that the shadows are always on the side opposite the light. Using an eraser, we restore the shape of the candelabra that was lost in the previous step.

Once again we take up the white pastel and finish coloring the candles by developing the gradation previously described. We apply highlights of white to the fruits and the fruit bowl to create reflections and emphasize the three-dimensionality.

The white parts of the fruits must be subtle, less intense than on the candles. To achieve this subtlety, we can color them using a blending stump containing some white, instead of using the stick.

It's a good idea to restore or retouch the shape of the candelabra, which will probably get lost during the process, to keep its shape from blending too much with the background or dissolving.

The halo of light from the candles is created with a simple tonal scale that begins in the stark white of the flame, passes through the intermediate tones created by coloring the background with brown, and ends in the intense gray and black in the background.

We further darken certain areas in the background and the shadow in the lower part of the fabric with a Conté crayon. All that remains is to add a few touches to the candelabra and blend the top edge of the table with the background by means of gradations. In some still lifes, the shadowy effect is used to suggest spirituality and a gloomy, enigmatic mood, with a dramatic sensation. Drawing by Mercedes Gaspar.

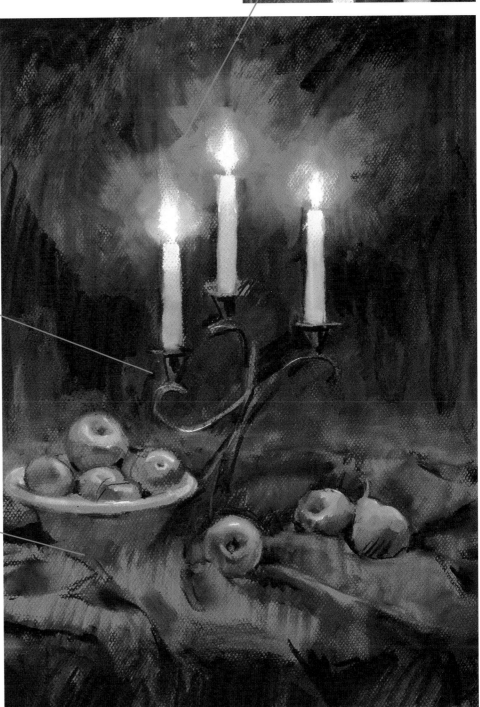

We use small reflections created with fine, subtle lines of white pastel to create the metallic texture of the candelabra.

The initial ochre color produces an excessively shiny effect, a contrast that is not well integrated into the shadowy, dark whole; thus we darken it with some intermediate tones by applying a light layer of charcoal with a blending stump.

The Effects of Light

Highlights are the reflections from the light source that are visible on shiny or highly illuminated objects. They commonly are applied in the last stage of a drawing to keep them from complicating the process of shading. For the white to stand out, they must be applied over areas that have previously been darkened.

Although the traditional way of drawing is to work the shapes of the model using lines and then developing the shadows, we will now see that a drawing can also be done by starting with the most brightly illuminated areas, by highlighting with white, erasures, or reserves, and then addressing the shadows.

Reversing the customary work process helps us consider the effect of direct light and correctly evaluate the effect of chiaroscuro in the model, because these are the aspects that demand our attention and guide us in the process of developing the drawing.

SKETCHING WITH LIGHT. In sketching a subject under strong illumination by using only light, very close observation of the light and how it strikes the model is crucial to the exclusion of shading. We will work on a grayish-blue paper that permits the greatest possible effect from lines and gradations done in white chalk.

14.1

AN EXPRESSIVE TREATMENT. Drawing presents an intentionally expressive mood, which we achieve by slightly distorting the interior space and the objects. Once the elements are outlined, we give them body by marking the most brightly illuminated areas with large swaths of white.

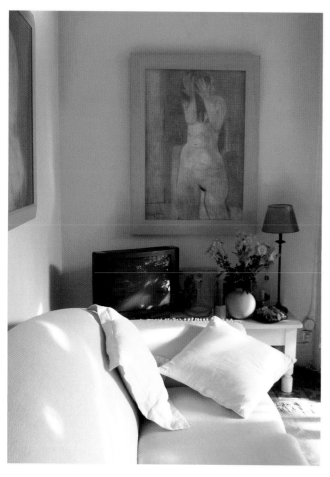

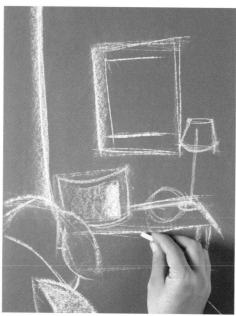

Before starting the sketch, we analyze the abstract characteristics of the space and the basic shapes. We first sketch with simple lines without paying much attention to the precision of the drawing. We even choose to distort the objects slightly.

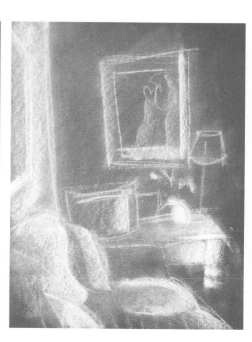

We add the touches of bright light with the side of a stick of chalk, bearing down on the paper to produce a coat of white that covers thoroughly. We focus on the abstract qualities of the colored areas instead of trying to reproduce the items precisely.

After coloring the most brightly illuminated areas in white with the side of a piece of chalk, we blend them with our hand.

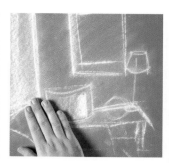

14.2

DEPICTING THE LIGHT. We add new passes in white to the illuminated objects and thus lighten the color of the paper. We modify the lighted areas using more varied and defining tones, properly combining the white of the chalk and the blue of the paper to produce a three-dimensional effect.

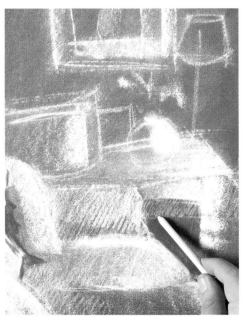

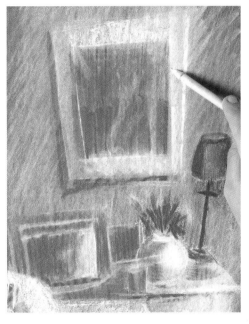

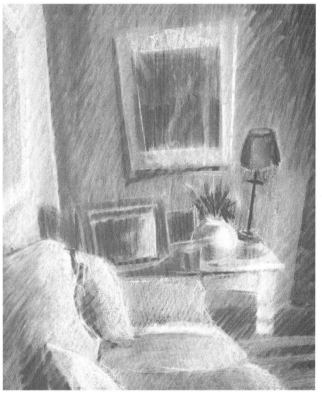

Using the tip of the stick, we define a little more clearly the shape of each object. We use lines to establish profiles. An eraser is used to darken the cushions. We create medium tones by adding new, very soft whites.

We apply gradations to the walls of the room using medium tones that are created using gentle strokes that don't entirely cover the color of the paper. This phase noticeably improves the overall appearance of the sketch.

The final step shows the many possibilities of an interior illustrated exclusively with white objects. Objects appear as negative shapes in dark gray that stand out from the light background. Drawing by Gabriel Martín.

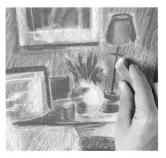

We restore the blue of the paper by opening up white areas with an eraser to create contrast and make the objects on the table stand out from the wall.

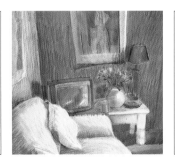

We can achieve a very attractive finish by creating chromatic contrasts with blue and orange colored pencils.

TONAL DRAWING ON COLORED PAPER. The color of the paper on which we draw is a factor that deserves consideration, because it's the base on which the lines will be done. In addition, the color of the paper is the color of the background in the drawing. It's advisable to select a medium tone so that it simultaneously contrasts with the whites and makes it possible to create everything from medium to dark grays and black.

15.1

A VERY LINEAR DRAWING. The layout involves a line drawing using a single stroke, with no shading. Before beginning to situate the lights, it's a good idea to have a perfectly constructed sketch. We will use an HB graphite pencil.

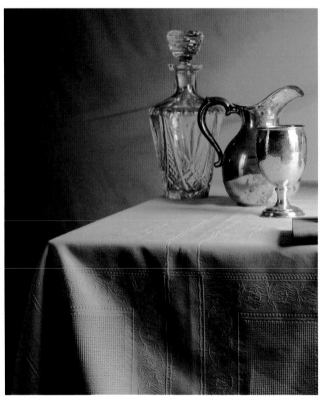

Using an HB graphite pencil we make a clear drawing of the shape of the table. Two or three straight lines and one curved one are adequate for creating the scene for the still life.

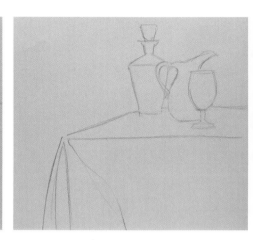

In a very linear and schematic way, we situate the glass bottle, the pitcher, and the cup on the table. All we need is a drawing using the outlines that suggests the shape of the objects, with no shading, reflections, or textures.

To prepare a tonal background on white paper, we cover it with flat charcoal and blend in the strokes with our hands. The medium gray must be even and dark enough so that the white stands out with force, yet light enough so that dark grays and blacks are possible.

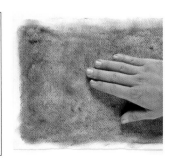

The initial treatment of the objects needs to be very schematic, without shading and details that impart textures.

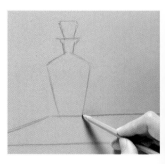

15.2

GRADATIONS ON GREEN. By adding gradations we set up the first tonal differences. Because of the contrast produced by black chalk, we distinguish the darkest tone, the lightest tone, which corresponds to the areas colored in white, and the medium tone, which is the color of the paper.

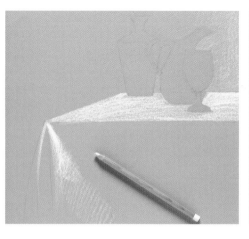

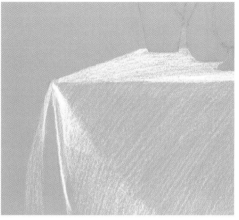

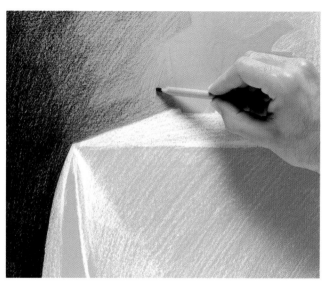

We use an eraser to lightly erase the graphite pencil. We leave a faint line—just enough to make out the sketch. Using a white chalk pencil we draw gradated white areas on the folds of the tablecloth and the background, and we color in the table using a continuous tone that covers well.

Using the white chalk pencil, we shade in the area of the tablecloth with a medium gray tone and customary diagonal lines, allowing the green of the background to breathe. To create longer, continuous strokes and keep the shading from appearing labored, we grasp the pencil at a point slightly higher than usual.

Using a black chalk pencil, we shade the background with a gradation ranging from the darkest black at the left of the picture to the green of the paper at the right. We leave blank the areas occupied by the objects.

Before starting to shade with chalk pencils, we must erase the graphite lines, because the chalk won't stick to them.

15.3

SHADING THE TABLECLOTH AND THE STILL LIFE. We intensify the contrasts in the previous gradations and blend the shadows. We project the shadows onto the table, develop the folds, and suggest the textures of the objects. Despite appearances, this phase is no more difficult than the previous ones, although we must study the shadows and the illuminated areas very carefully.

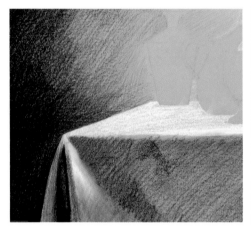

Now we will combine black and white in a single area. We shade in the wrinkle in the tablecloth using black chalk, and apply a gentler shading to the part that hangs down.

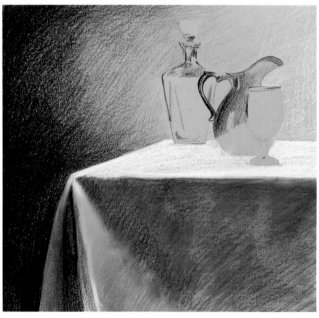

We blend in both colors using the tips of our fingers to soften the transition from one tone to the other. The gray appears more whitish on the fold, and a darker tone prevails elsewhere.

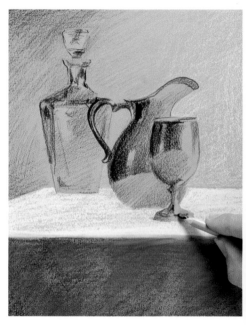

We shade in the objects using just two values. We represent the pitcher and the cup with gradations and the glass bottle with softer shading to provide credibility for the shape, creating strips that help us describe the smooth texture and the reflections.

In blending with our fingers the shading done in black and white chalk, we create a gray color with a certain violet tint. The blending softens the transitions from one color to another.

By blending with the tips of our fingers, we eliminate any remaining visible lines, which bother many artists.

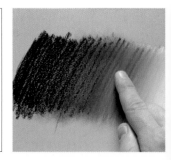

The background consists of a gradation made up of grays, in which the pencil lines are still visible. The color of the paper plays an important role in harmonizing the entire work.

To complete the drawing, we locate a few reflections on the objects in the still life. In the final product we can see that the pronounced contrast between the white and the black on the green paper highlights the effects of chiaroscuro, defines the areas of light much more effectively, and creates darker shadows. Drawing by Óscar Sanchís.

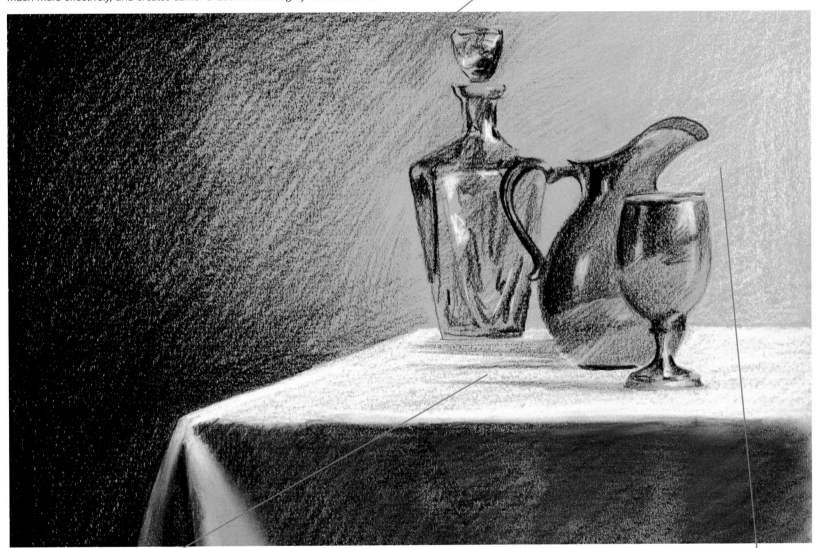

The shadows projected onto the tablecloth don't show much contrast; they are in a very light gray that just makes them identifiable. It's necessary to use the tip of a blending stump to work in such a small space.

The highlights have to be very subtle. If necessary, we run our finger over the reflections to blend them into the surface of the object.

BACKLIGHTING IN LANDSCAPE. The effect of backlighting in a landscape tends to darken the foreground, place shapes in silhouette, and intensify the luminosity in the sky. Sunbeams invade the landscape and blur outlines, creating gradations of light that diffuse the features of the cliffs, as through a glaze.

16.1

SHADING THE PLANES. Before dealing with the backlighting, we use sanguine to shade the nearest planes of the landscape, and bister (a fairly dark brown) on the cliffs in the background.

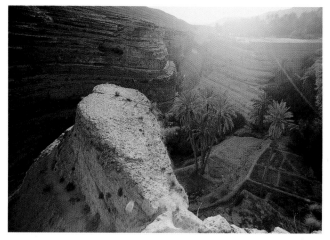

We separate the main planes of the picture by drawing the outlines of the rocks with an HB graphite pencil, without addressing textures, vegetation, and other details, since we will cover everything with shading in chalk.

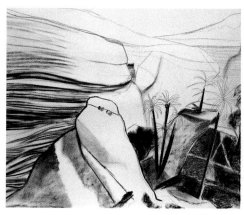

We intensify the outlines on the outcropping in the foreground and the trunks of the palm trees with black chalk. Using bister chalk, we begin to darken the terrain on the right and the rocks of the cliff, which we represent with a succession of curved, thick lines.

If we have any difficulty with certain details of the landscape, we can use a preliminary sketch. All we need is a few lines to serve as a guide for spreading out the shading.

To provide contrast for the leaves of the palm tree in the background, we color them in schematically with dark lines in sanguine.

16.2

BACKLIGHTING WITH WHITE CHALK. To create an effect of backlighting in a landscape, we darken the background with more shading. The sky must remain white, and the strokes in white chalk must spread out in a fan shape, like a light that fills the landscape and inhibits our view of the outlines of the rocks in the distant plane.

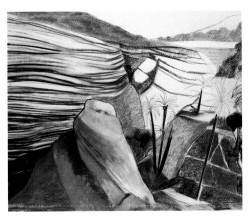

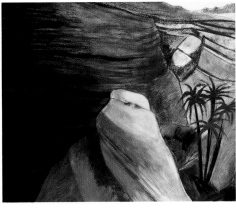

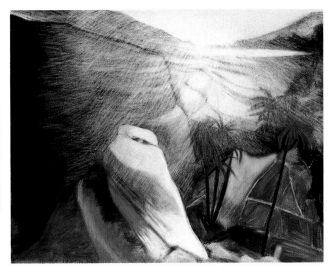

Using the stick of sanguine, we shade in the rock outcropping in the foreground. Because the sanguine is a warm color, it's most appropriate for the close planes. Dark shading predominates in the rest of the drawing.

We can create a dark tone by using our hand to blend the bister shading with the dark lines of the cliff in the background. Working with a blending stump and the modeling effect make it possible to depict the shape of the rock in the foreground correctly.

Once we have finished the shading of the landscape, we color in the sky. Using a stick of white chalk, we extend a hatching of concentric lines that diminish in intensity as they get farther from the sky. The hatching begins at a single point in the sky and fills the whole drawing. Drawing by Almudena Carreño.

The lines done in chalk represent the rays of the sun that fill the landscape. Their intensity needs to diminish as a function of their distance from the light source, forming a gradation of whites.

SKETCHES IN WHITE. If we use paper of a medium tone, we can do an interesting exercise in sketching with white plaster, chalk, or pastels. By coloring with the side of the stick, we can create attractive studies of light.

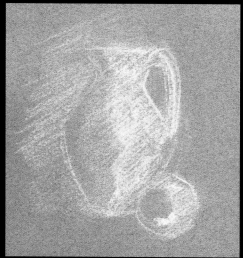

Sketch for a still life done in white colored pencil. The shaded areas are left in the color of the paper.

Using a few colored areas done with the side of a stick of chalk, we create a synthetic sketch of how the light strikes the subject.

GRADATIONS OF LIGHT. Just as we use gradations of shadows to make the model appear more three-dimensional, we can use gradations of light for the same purpose.

Three gradations on a gray background: white pencil (A), a stick of chalk (B), and Conté pencil (C).

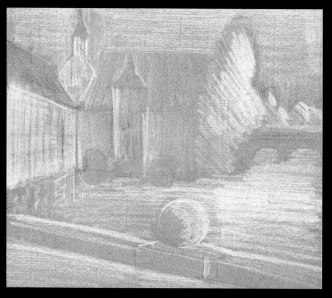

This urban landscape was done entirely with Conté pencil, using gradations of light.

HIGHLIGHTING AND THREE-DIMENSIONALITY. Accents of light presume the direct presence of the source of light on the objects in the shape of light spots or intense reflections. They also contribute to underlining the shape through their strong contrast with shaded areas.

LIGHT THROUGH LINES. To recreate the beams of light that fill a scene, we can draw the light using a series of parallel, diagonal lines.

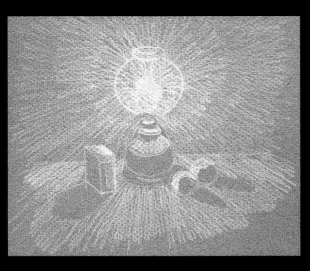

If we include the light source in the same still life, we can draw the beams of light using radial strokes that originate with the lamp.

COLORING THE SKY WHITE. Some illustrators who specialize in landscapes commonly color the sky white to give the landscape greater luminosity, highlight the contrasts, and reaffirm the shape of the horizon and the crowns of the trees.

In this landscape, a layer of white gouache has been applied to the sky to highlight the outline of the mountains.

CONTROLLING INTENSITY. The intensity of the white used for highlighting details or representing light depends on the pressure applied with the drawing implement. A line of intense white is very difficult to erase if a mistake is made, so it's a good idea to proceed judiciously and avoid exaggerating the reflections, especially in the early stages.

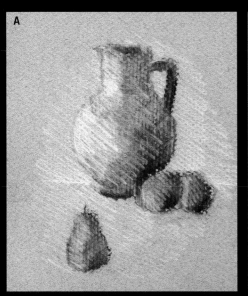

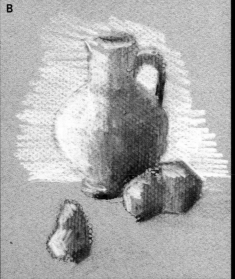

Here we see two different treatments of the highlights done in chalk: a still life with gentle highlighting (A), and another one using highly contrasted and forceful highlights (B).

ERASURE TECHNIQUES. Now we will combine work with graphite and an eraser on the same support. The eraser is used in precisely the same manner as a pencil or any other means of drawing. In a drawing done with shadows, the areas to be illuminated are erased to restore the white of the paper and create sharp contrasts with the adjacent areas.

17.1

LINES AND CURVES. To draw architectural scenes such as this one, we use diagonal straight and curved lines that locate each of the façades by creating the effect of perspective in the street.

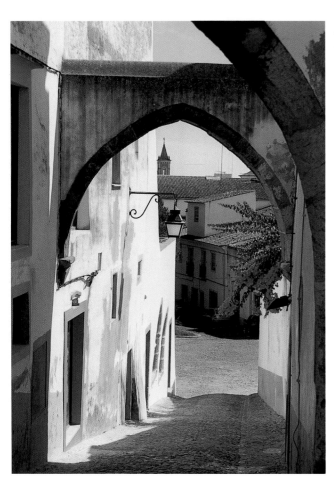

Using a dull 2B graphite lead we draw the diagonal lines that define the perspective of the street. We use a few curved lines to sketch the arch. We don't have to pay much attention to detail, because we are not aiming for a very realistic drawing.

We firm up the sketch by rendering the model with a new series of bolder lines. We can superimpose several lines with the intention of choosing the right one, for this is still an exploratory stage.

In urban scenes, the direction of the strokes is important. In this instance, most of the lines move in perspective toward the background.

Professional artists commonly superimpose several lines to firm up outlines when they sketch. When the drawing is a little more advanced, we select the most appropriate lines and erase the rest.

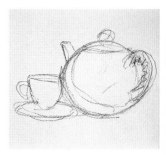

17.2

APPLYING THE MEDIUM TONES. To open up light areas with an eraser, we need to darken the surface of the paper with shading done with the flat side of a graphite stick and smoothed out with the hand. That way we create an overall medium tone that favors contrast. Drawing with an eraser is particularly indicated when the subject presents marked contrasts of chiaroscuro.

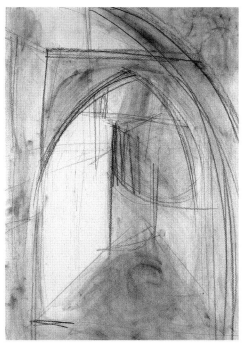

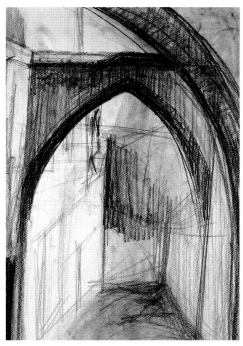

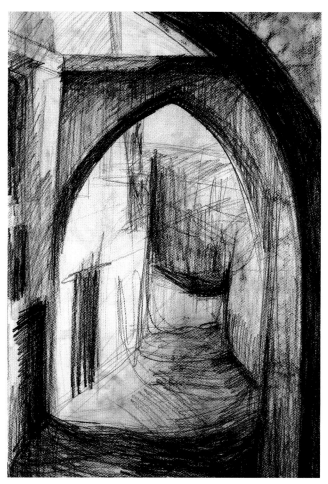

We impregnate a piece of cotton with graphite powder and apply a faint gray to the surface of the paper. We continue darkening the paper with the side of a square stick of graphite.

We add contrast to the arches in the foreground with traditional grays that are applied rapidly and appear agitated and rather imprecise. We accentuate the shape of the arches with thick, dark lines. We use our hand to blend the shading as it is added.

We intensify the graphite lines in the first and second planes, thus creating a fairly dark, medium tone. The contrast is very important in resolving the light and dark areas in every area. The shading is not very precise, and it barely addresses details and shapes.

The darker the tone of the shading, the greater the contrast with the light areas opened up with the eraser.

We shade in very quickly with the stick of graphite held on its side.

17.3

ERASING. Now is the time to use the eraser as a drawing implement. We use it to lighten the illuminated areas, refine the quality of lines and tone, and create highlights where the drawing presents a continuous tone.

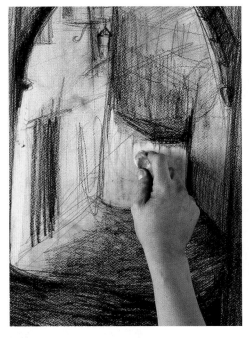

We erase partially to lighten the areas of minimal light, such as the far end of the alley. The tone lightens as we pass the eraser over it gently. This effect can be used carefully to suggest the medium and dark tones.

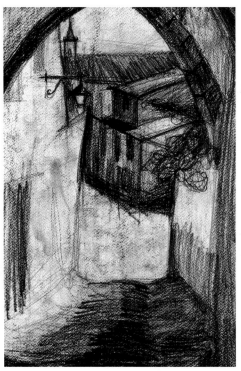

We use the graphite lead to provide contrast to the texture of the surface of the street through lines of varying intensity. We use thick, shaded lines to draw the series of houses at the end of the street.

We use the edge of the eraser to open up the light areas on the façades bathed in sunlight. The harder we press with the eraser, or the more frequently we repeat the stroke, the brighter the white areas.

The eraser becomes soiled with pigment, so it is necessary to clean it from time to time. To do that, we merely need to rub it on a clean sheet of paper.

The technique of drawing with an eraser works only on smooth paper. On very rough papers, the pencil lead usually penetrates into the fibers, making it very difficult to remove the marks.

Because there are many ways to use the eraser, we need to diversify its use. If we always move it in the same direction, the drawing will appear static and flat. Thus it's appropriate to change the angle of the stroke we apply with the eraser, or to cross the eraser strokes.

Once the effects of erasing are done, we use the sharp point of a graphite lead to resolve the architectural details of the doors, windows, streetlights, and joints between the stones in the arch. The doors and windows appear in strong contrast. Drawing by Esther Olivé de Puig.

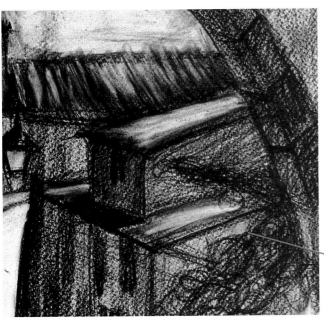

These erasure techniques are very useful in creating angles of light and reflections in dark, tonal areas.

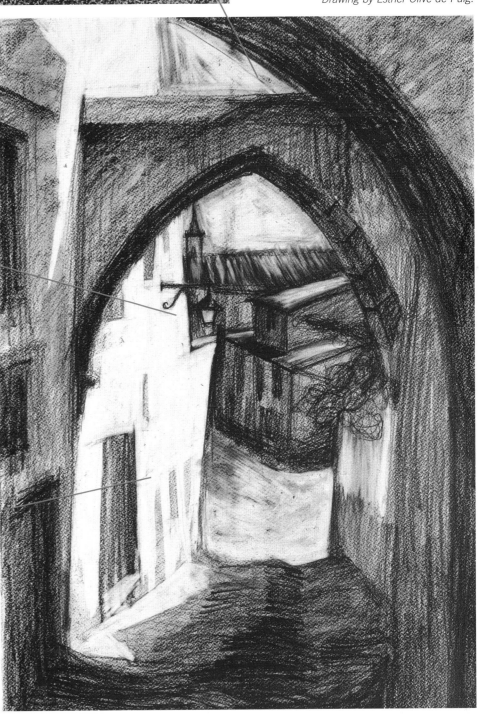

Between individual erasure strokes we leave small spaces in the previous shading to represent the rough texture of the wall.

LIGHTENING WITH CHARCOAL AND CHALK. It's fairly easy to lighten an area of shading done with charcoal or chalk. All we have to do is go over the surface with a clean cloth or the tips of the fingers to remove part of the layer of pigment.

We can lighten charcoal by using a kneaded eraser.

To soften the light areas we go over them with the tip of a cotton cloth.

SKETCHES WITH LIGHTENING EFFECT. In learning to draw light, a good exercise involves doing sketches by lightening a gray base with an eraser. Therefore, we will do some brief studies in which the presence of light helps us identify the outline of the objects.

OPENING UP LIGHT AREAS IN CHARCOAL. The most effective way to open up light areas in charcoal is to use a kneaded eraser, for the particles of pigment can be removed cleanly from the paper without having to rub excessively. To erase broad areas we use the kneaded eraser in the shape of a ball; to create small touches of light, we mold it into a cone shape and erase with the tip.

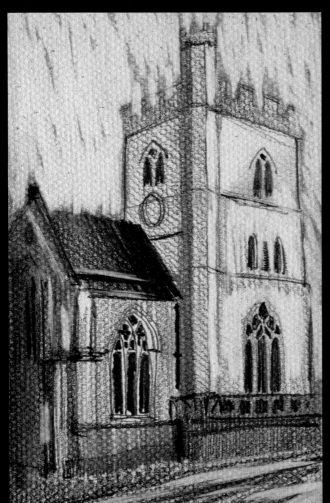

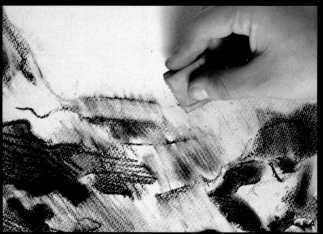

The kneaded eraser is very useful for lightening areas when working with charcoal or chalk.

In this sketch of a church, areas on the façade and in the sky have been lightened using an eraser.

Even lightening using an eraser on graphite shading.

Erasure in the form of a gradation on graphite shading.

LIGHTENING. This technique involves removing a little pigment to uncover the white of the paper in certain areas or points. In drawing with charcoal or chalk, this is a usual practice for introducing a point of light in a tonal area.

HATCHING WITH THE ERASER. We can apply a series of linear hatchings with the tip of an eraser or an eraser pencil applied to an area previously shaded. We can also produce linear drawings using the eraser on a background of blended color.

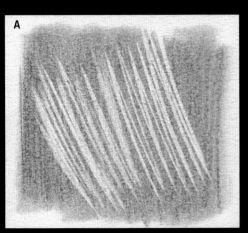

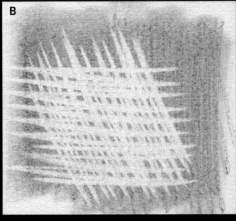

Two possibilities of hatchings done with an eraser: the traditional hatching (A), and crosshatching (B).

BLENDING WITH AN ERASER. An eraser is not just an implement for opening up light areas; it's also an excellent way to blend. If we make an even pass with it over a previously shaded drawing, it unifies the whole with a series of lines reminiscent of a drawing done with hatching.

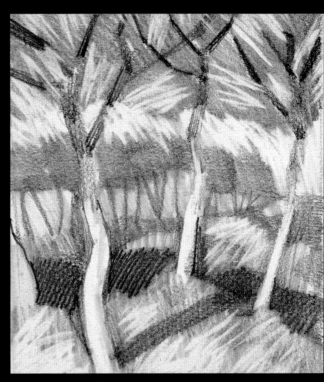

In this landscape sketch, the texture of the vegetation has been created using hatching produced by an eraser.

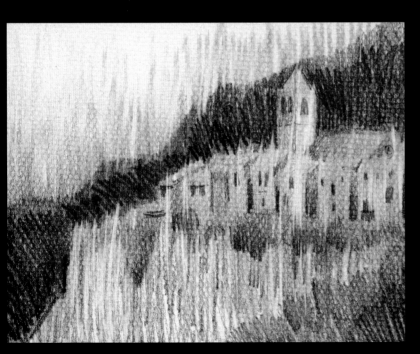

If we use an eraser to blend an existing tonal drawing, we achieve an atmospheric effect with very pronounced lines.

Blending effect done with an eraser.

The shape of the objects in the room must be understood as a series of simplified geometrical figures. In that context, the light is depicted by creating gradations with a white pencil.

The artist resolves the texture of the folds in the tablecloth using wavy hatchings, which are superimposed over the gradations that establish the shape.

The key to the representation of the indoor space in this drawing involves controlling the gradation that we apply on the walls to explain the origin of the light and the amplitude of the space. Here are two examples: The first (A) is similar to the one in the drawing; the second one (B) represents a room illuminated by a window that opens in the wall in the background.

Imagine that the effect of light from the bulbs in the lamp that hangs from the ceiling is achieved by superimposing over the white of the background a series of radial lines originating from the illuminated lightbulb. This is another example of the addition of lines to the preliminary shading.

INTERIOR IN WHITE PENCIL. The possibilities of drawing with nothing more than a white pencil on colored paper are vast, and exploring them is worthwhile. Using white chalk on colored paper, it is possible to achieve a very broad scale. Objects take on shape thanks to the light. It's not necessary to depict the shadows, because the darkest color is that of the paper.

When the artist finds it difficult to differentiate between two adjacent zones that exhibit the same tone of white, the most appropriate course is to change the direction of the strokes. Then the difference is not communicated through tone, but rather through contrasting lines.

The artist has placed greater emphasis on lines and hatching on top of the initial gradations. Whereas the gradations set up the sense of space, the lines provide details and clarify the shapes.

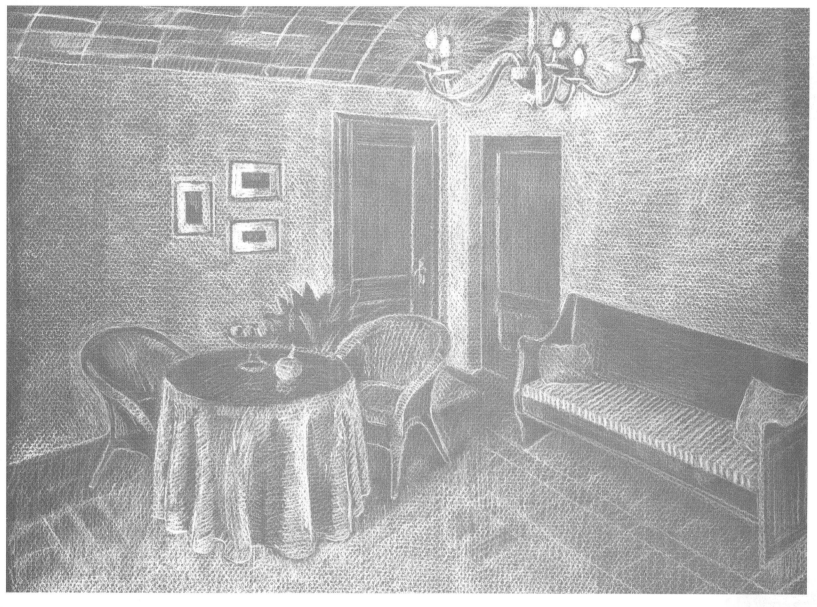

DRAWING IN WHITE. Using a white piece of chalk or pencil, it is possible to draw a model by merely representing the areas of light, without addressing the shadows, which remain in the color of the paper, preferably a medium tone. In these drawings it is not necessary to use any darker colored pencil or stick.

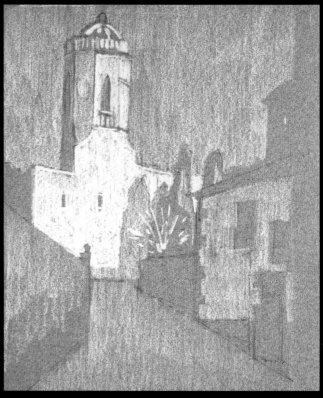

DRAWING IN NEGATIVE. If we work with white paper, the usual practice involves darkening the shadows and leaving the illuminated areas white. However, when drawing on a dark colored paper, we have to work in reverse, progressively lightening the illuminated areas with light colored chalk or pastel. Drawing in this way is neither easier nor more difficult than drawing in the conventional manner; we merely have to work in reverse.

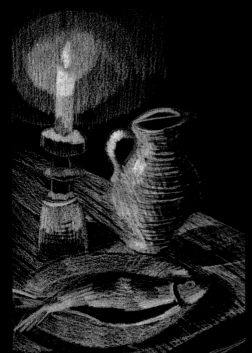

Lightening on a dark paper is done using white, and is reminiscent of a reversal of a gradation in grays.

In this rural scene, we use white to color the areas that receive direct light; the result is a convincing representation.

BLACK AND WHITE. By combining black and white on a neutral support (ochre or medium blue), we can produce three-dimensional results that suggest marble relief. In these instances it's appropriate to exercise care with the gradations from one color to another and avoid dramatic contrasts.

To draw with white on black paper, we have to paint the light as if we were dealing with a photo negative.

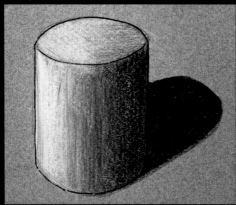

The previous gradation is incorporated into a cylindrical shape to reproduce the effect

The tonal gradation from white to black presents great contrast. It is appropriate for highly three-dimensional works.

DRAWING WITH WHITE. White is commonly used in the finishing phase to emphasize the illuminated parts of the model, represent reflections, or depict the light source if it appears within the drawing. It may also be a drawing medium unto itself, which may be omitted or complemented by a few strokes done in a dark color.

FORTUITOUS WHITE. When we draw with charcoal on colored paper, the use of white can be fortuitous in emphasizing contrasts, giving life to a dull subject, activating the expressive tone of the drawing, and highlighting the effect of three-dimensionality.

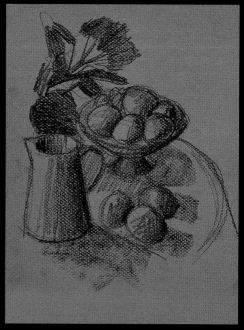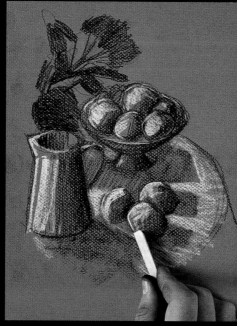

In comparing these two drawings we can see that the use of white chalk heightens the expressiveness, thanks to the greater contrast between the illuminated and shaded areas.

AVOIDING AN EXCESS OF WHITE. When we use white chalk to highlight the reflections on a model, we must avoid the error of saturating the objects with this color. Otherwise we lose the expressive force of the highlights when they are applied correctly, with restraint, and in small, pinpoint areas.

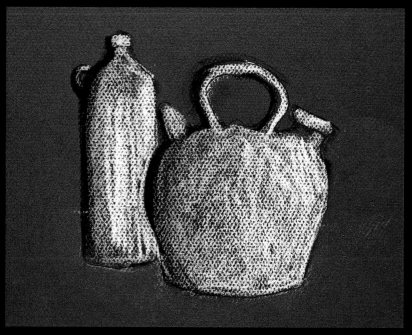

Here is an example of a still life that shows excessive use of white. By covering nearly the whole surface of the object in white, we lose the highlighting effect and the sense of three-dimensionality.